CREATURE CORNERS

◦ A BOOK TO TRACE & COLOR ◦

BRITTANY MEREDITH

A TARCHERPERIGEE BOOK

tarcherperigee

an imprint of Penguin Random House LLC
penguinrandomhouse.com

Most TarcherPerigee books are available at special quantity discounts for bulk purchase
for sales promotions, premiums, fundraising, and educational needs. Special books or
book excerpts also can be created to fit specific needs. For details, write
SpecialMarkets@penguinrandomhouse.com.

ISBN 9780593713372

Printed in China

10 9 8 7 6 5 4 3 2 1

Book design by Lorie Pagnozzi

WELCOME TO

CREATURE CORNERS:

A BOOK TO TRACE AND COLOR!

HELLO!

Hi, I'm Brittany, and I'm an author and illustrator living in Georgia, the Peach State. I've always had a passion for drawing and I love reading manga, so I pursued an education in the comics industry, where I learned about the many layers of creating a comic.

Each layer of a comic has its own magic. *Creature Corners* is inspired by the layer known as "inking." Comic artists will use non-photo blue, the same color in this book, for preliminary sketches, and they'll ink directly over these lines for a final, clean illustration.

Inside this book you will discover a delightful world of unique storefronts and the quirky animals that run them, ranging from a fish stall run by an ex-pirate bear named Angler Ted, a snail-mail post office run by a sloth, and many other fun scenes to explore.

The blue lines in the art serve as a guide for you to trace with ink. This is where the magic of inking happens! By outlining or tracing over the original lines in the drawing with your preferred inking tool, you can give the artwork its own character, setting the mood with bold or delicate lines, creating light and shadows, adding texture, and playing with line weight. Have fun experimenting and making the drawings uniquely yours!

The most common ways to ink are with a variety of inking tools, such as these:

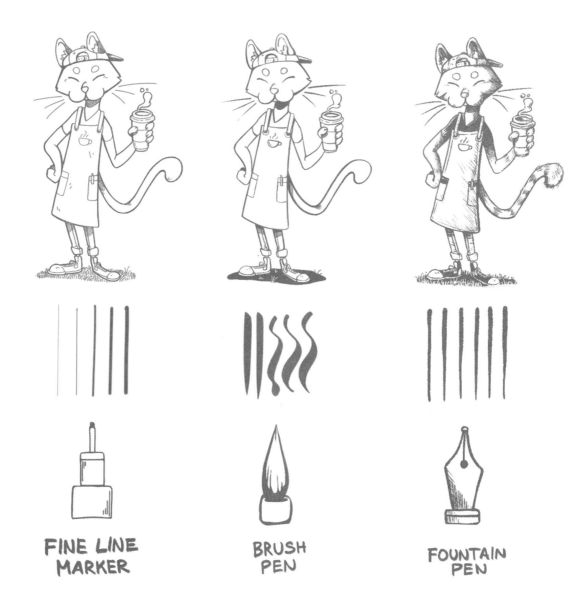

FINE LINE MARKER **BRUSH PEN** **FOUNTAIN PEN**

After you've finished inking your page, it's time to add some color! Whether you choose colored pencils, markers, or paint, your colors will pop against the dark ink.

Or you can skip the inking and go straight to coloring! There is no "right" way to use this book. Have fun experimenting with various inks and colors, and go in whichever order you please.

It doesn't matter if you are an aspiring artist or just need some time for self-care. Each page is waiting for you to discover its magic and bring it to life.

Enjoy!

SOME TIPS:

- Don't worry about inking or tracing the blue lines perfectly.

- To prevent transfer of heavy markers or paint through your pages, slip a blank sheet of paper behind the page you are working on. Or test the tools on a separate piece of paper for bleeding.

- Give yourself the freedom to explore different inking tools. Each one creates a different visual effect and will feel different in your hand.

- Ink can be unforgiving. If you feel like you've made a mistake, allow yourself the creative freedom to incorporate that mistake into your work—turning it into a "happy accident."

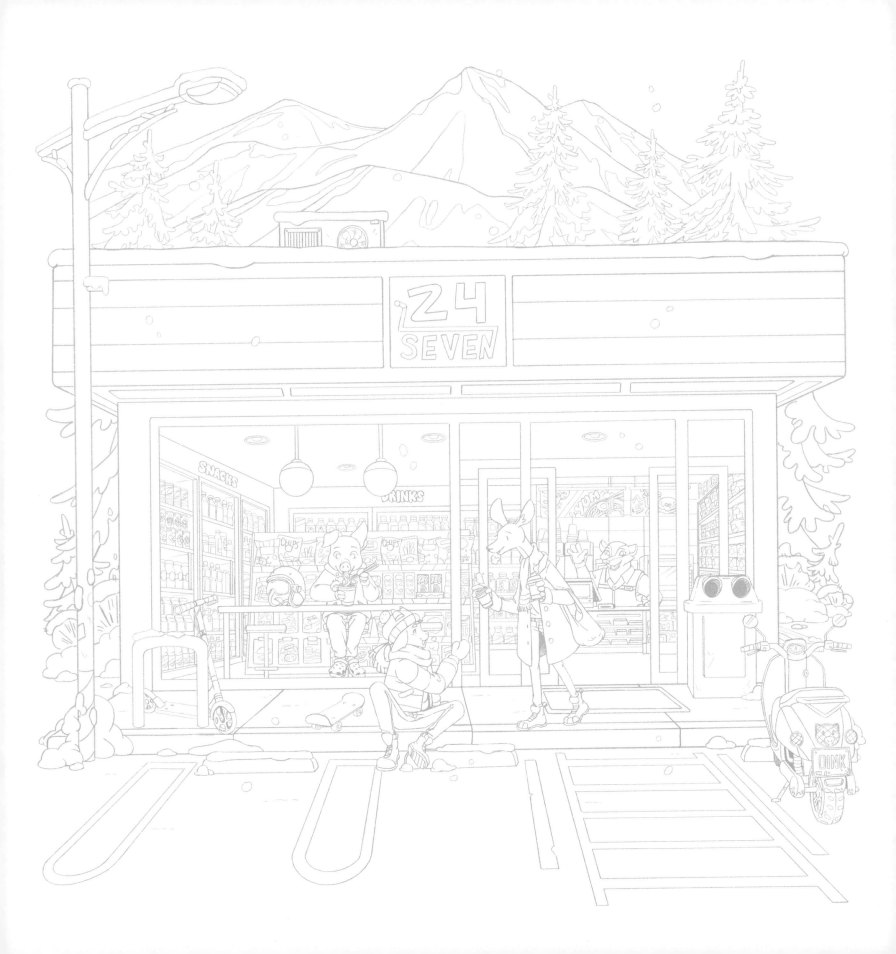

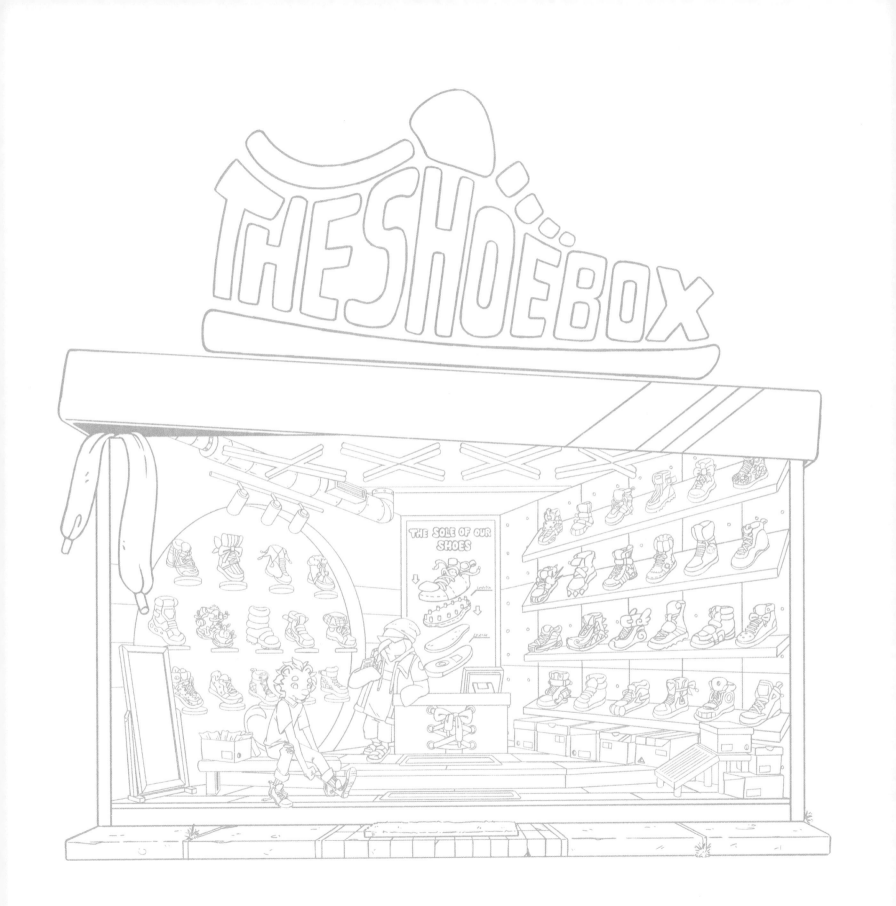

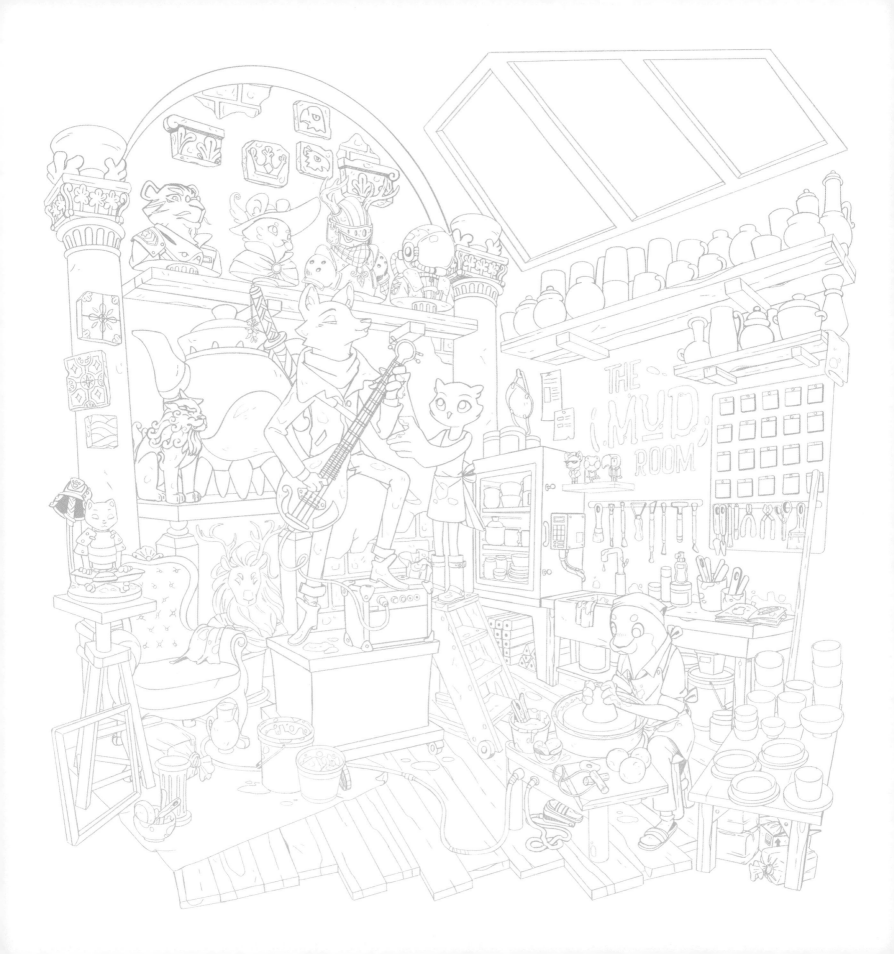

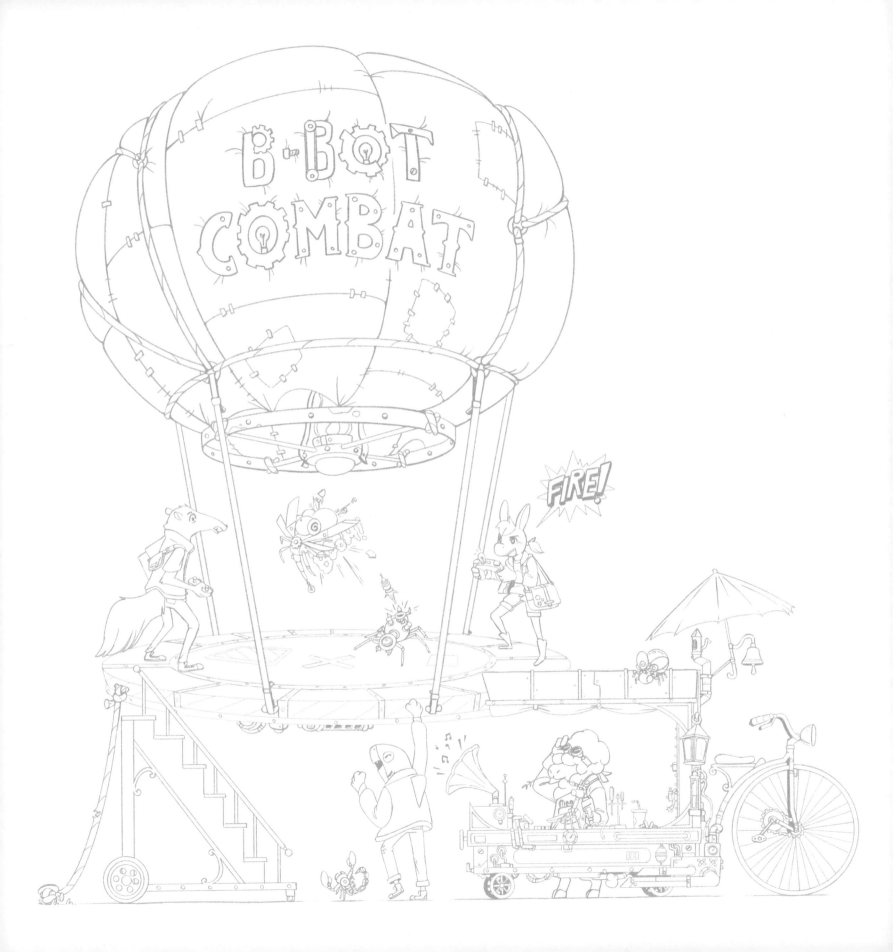

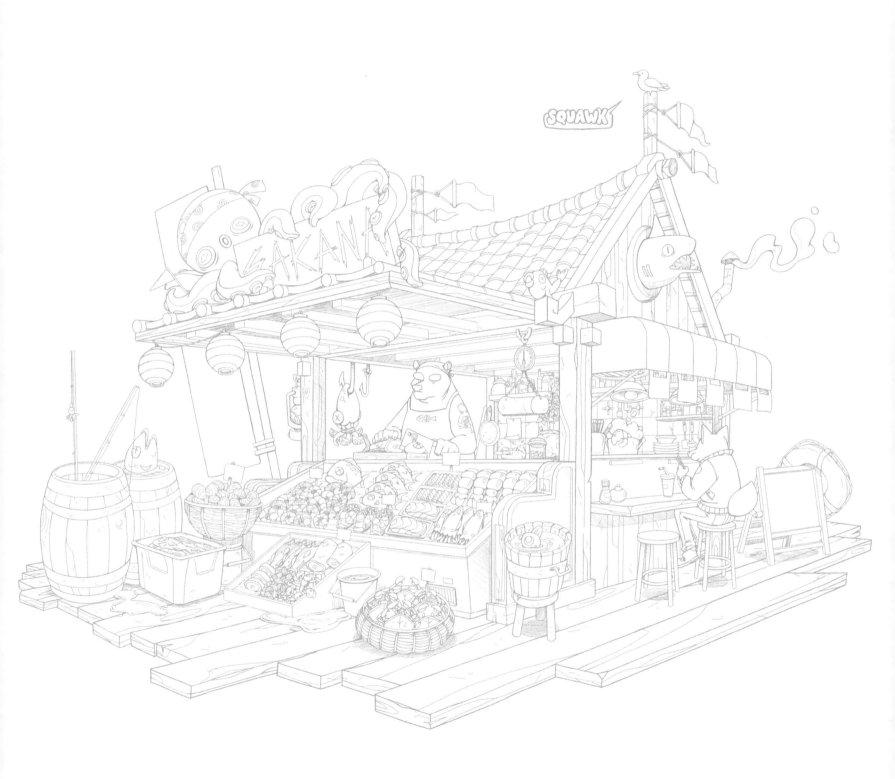

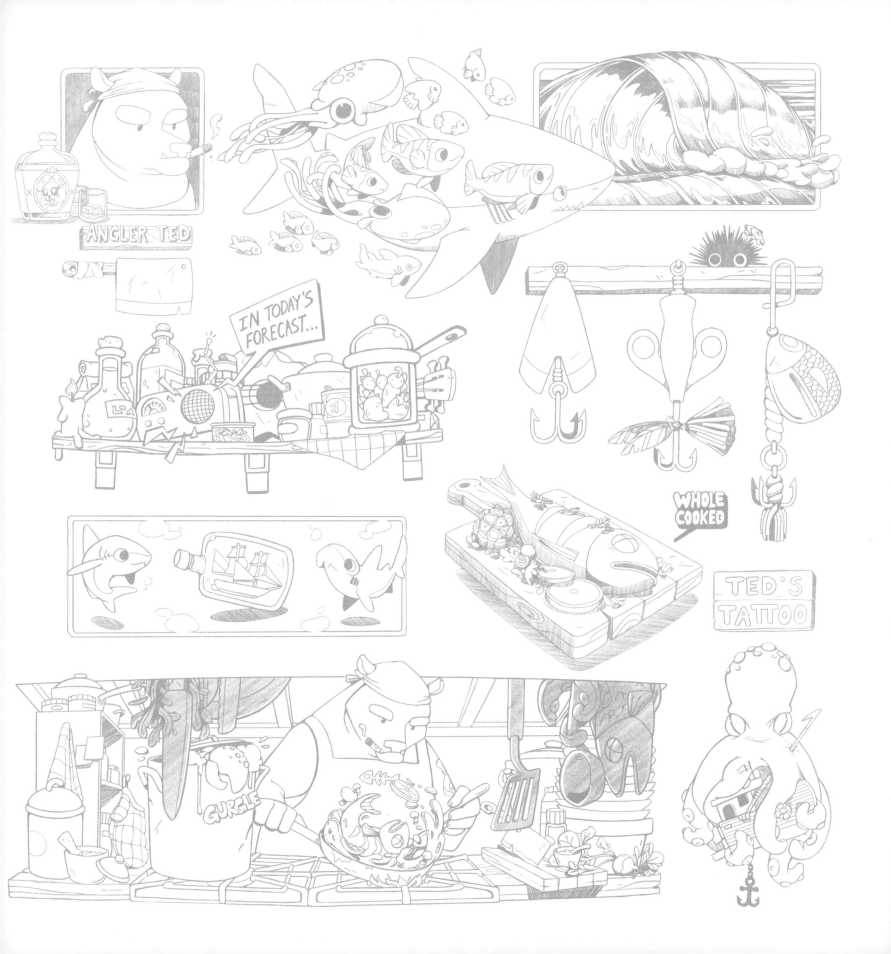

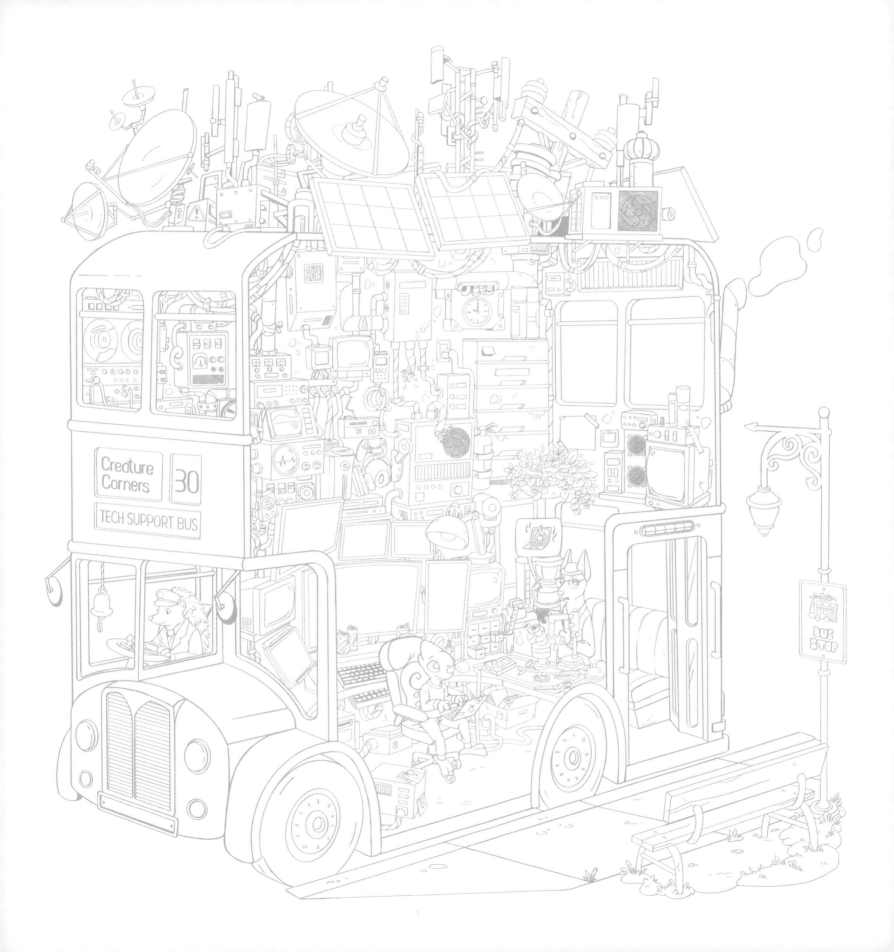

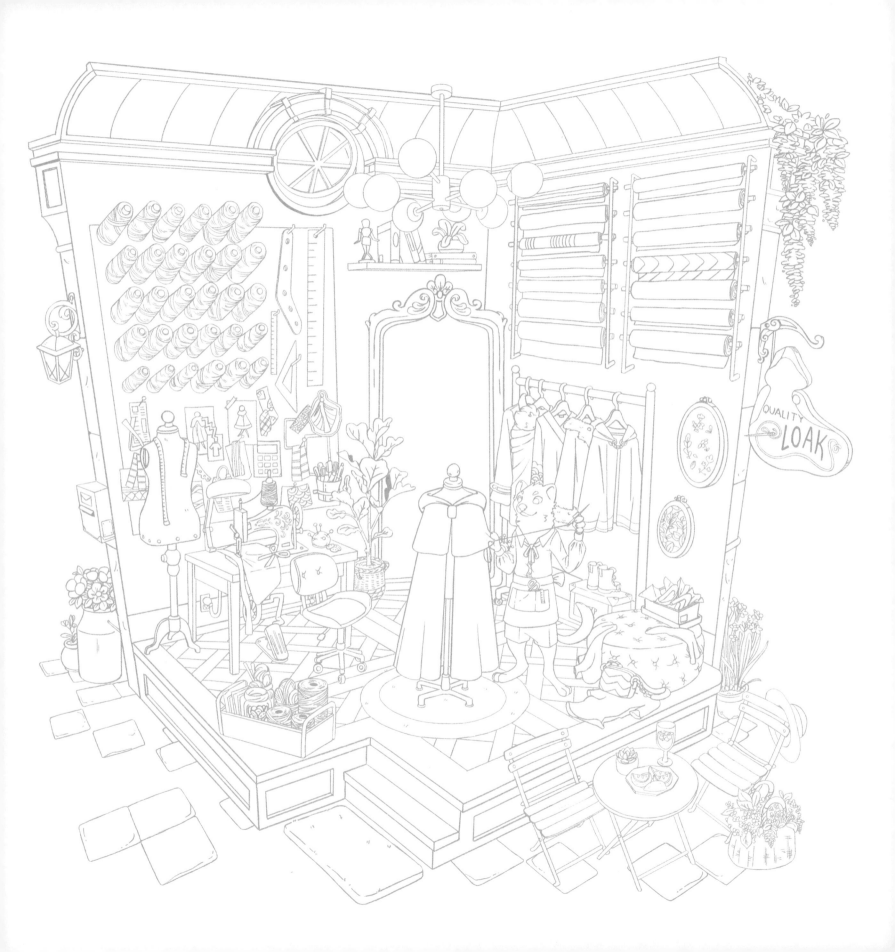

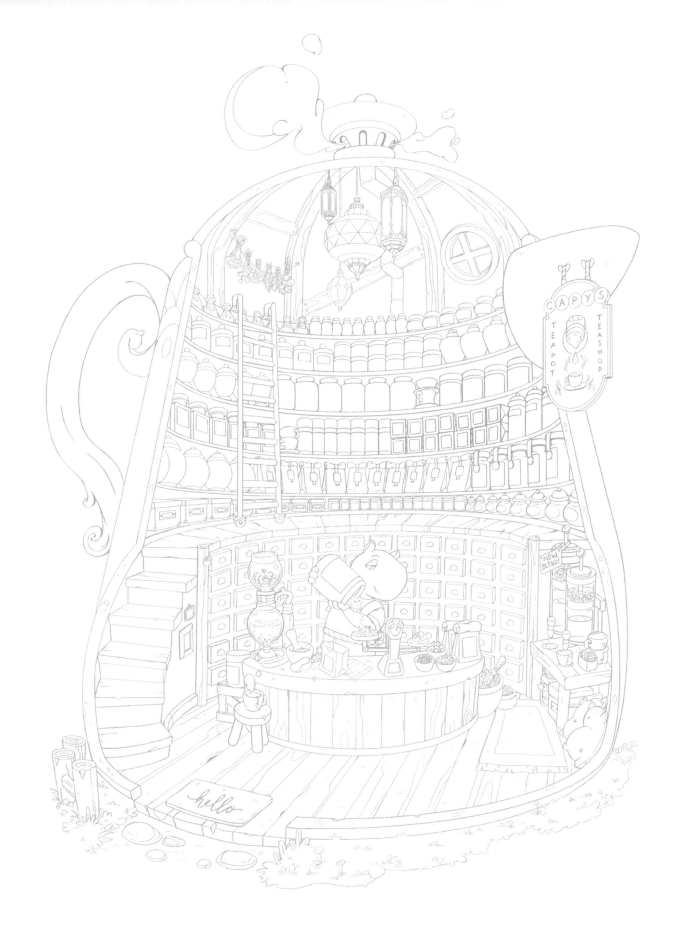

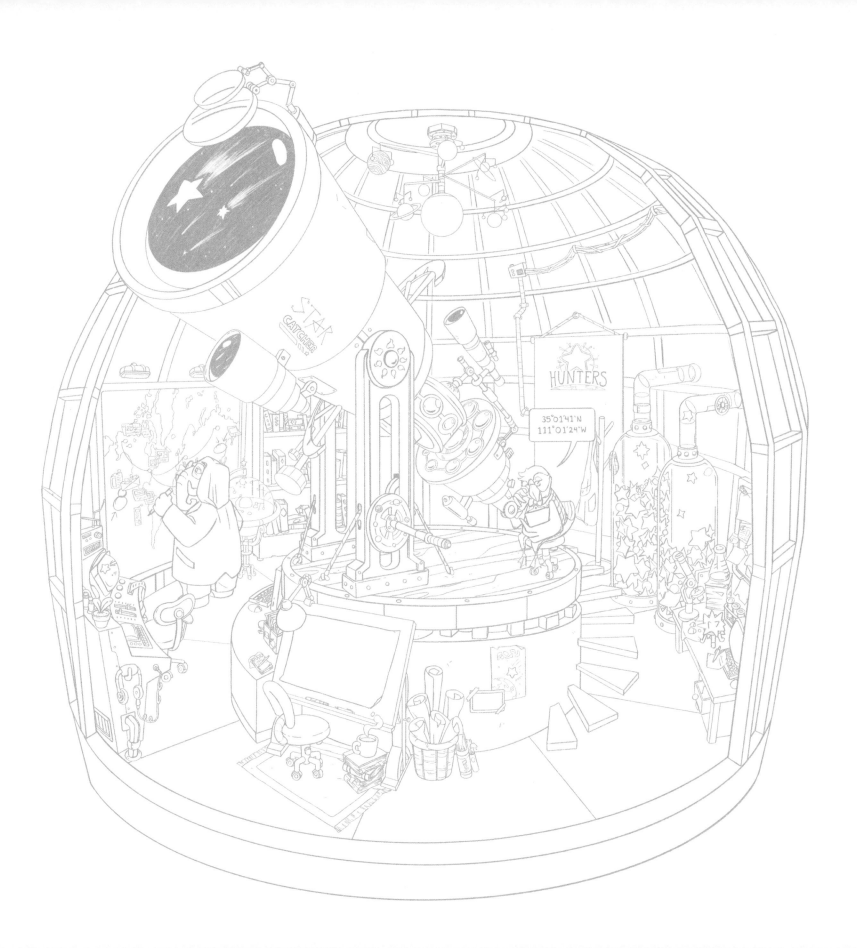

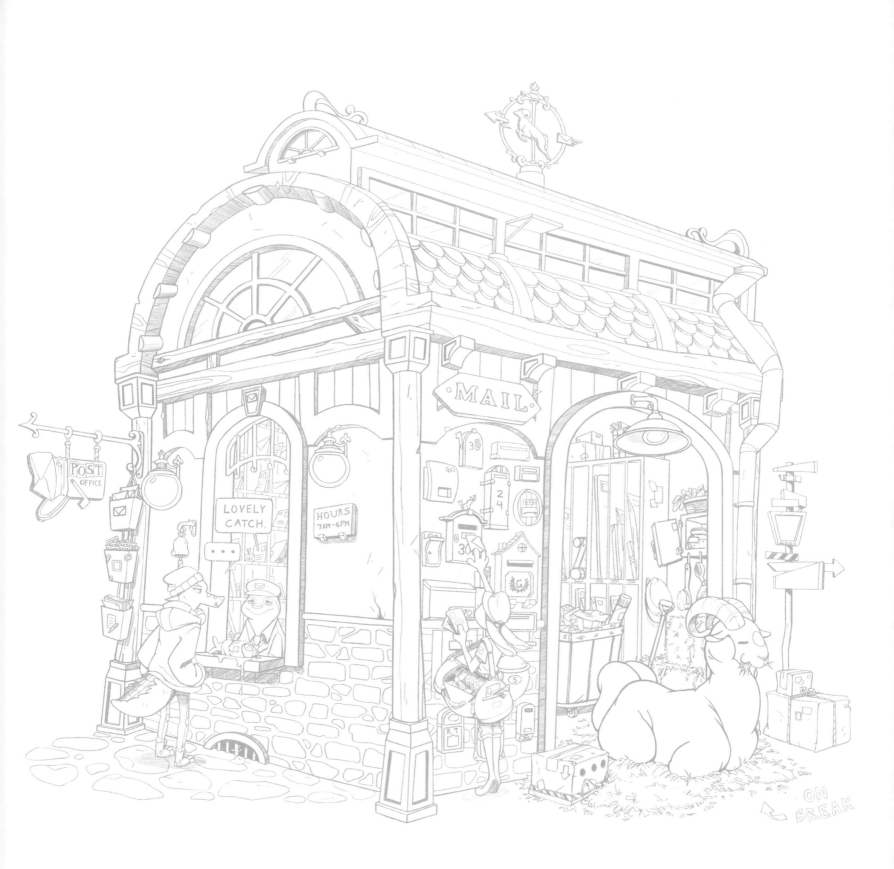

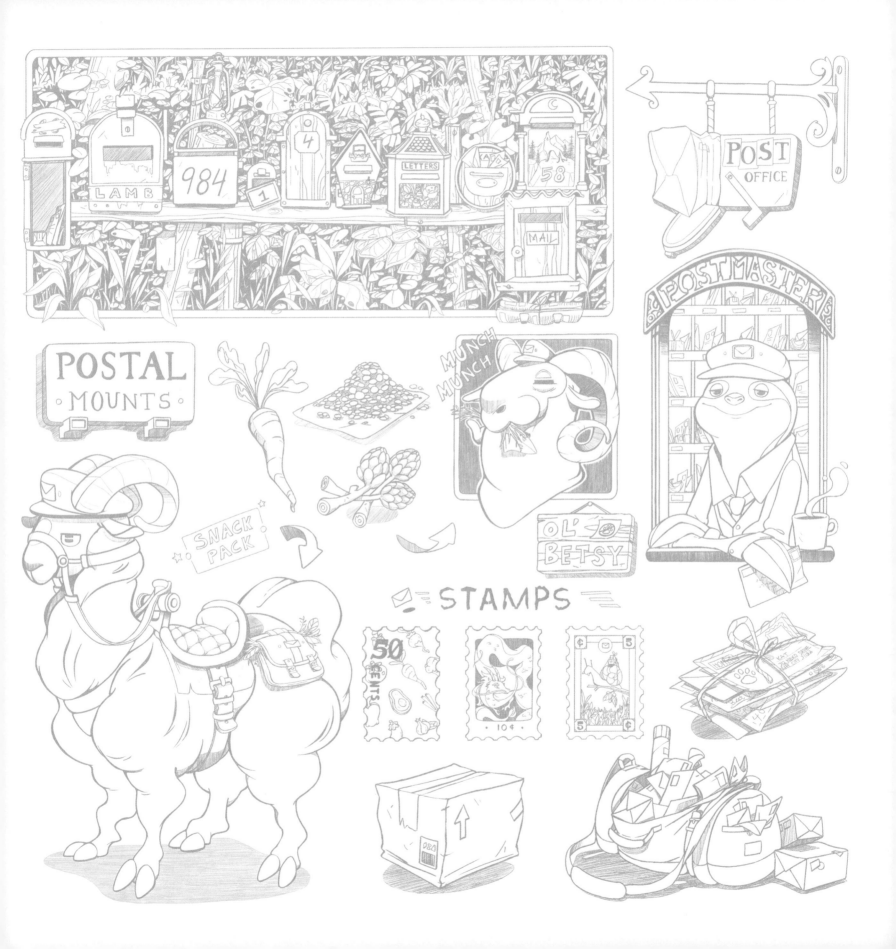

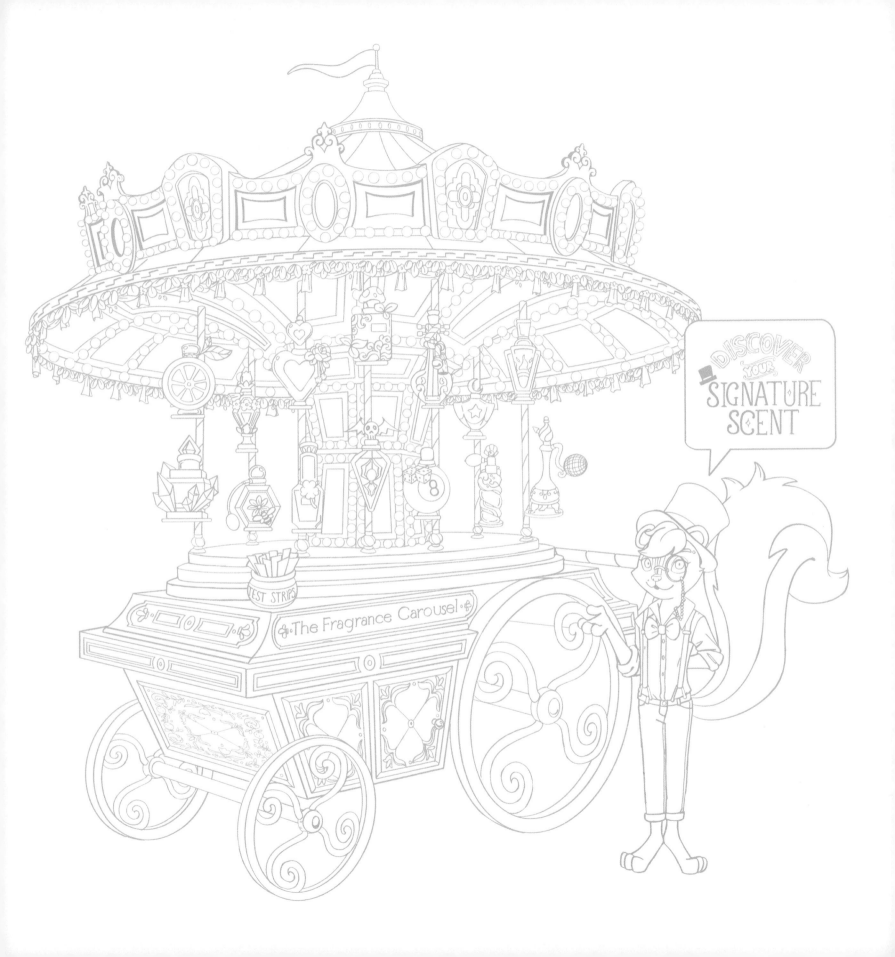

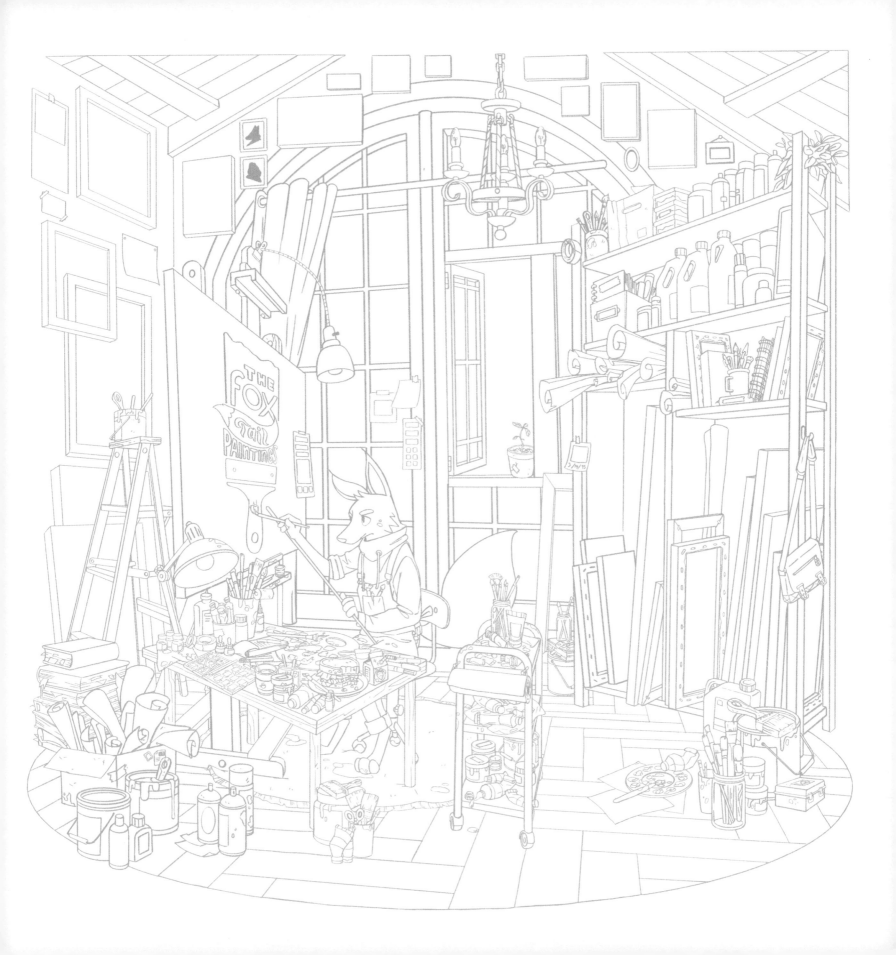

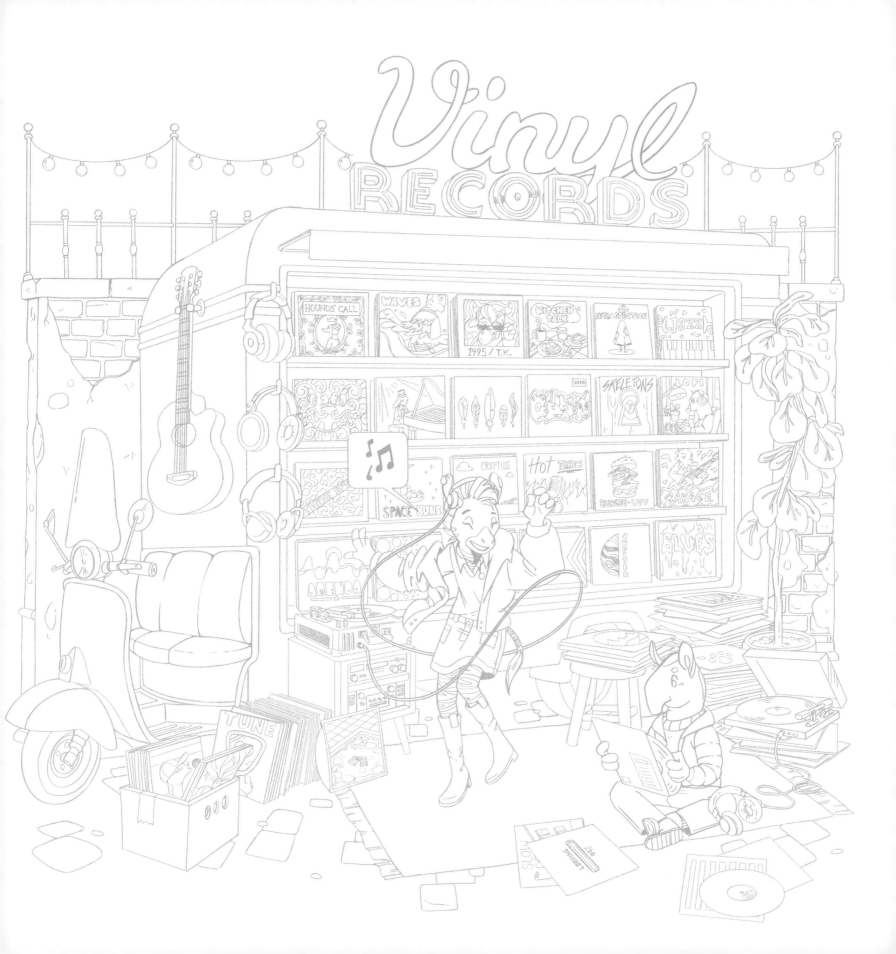

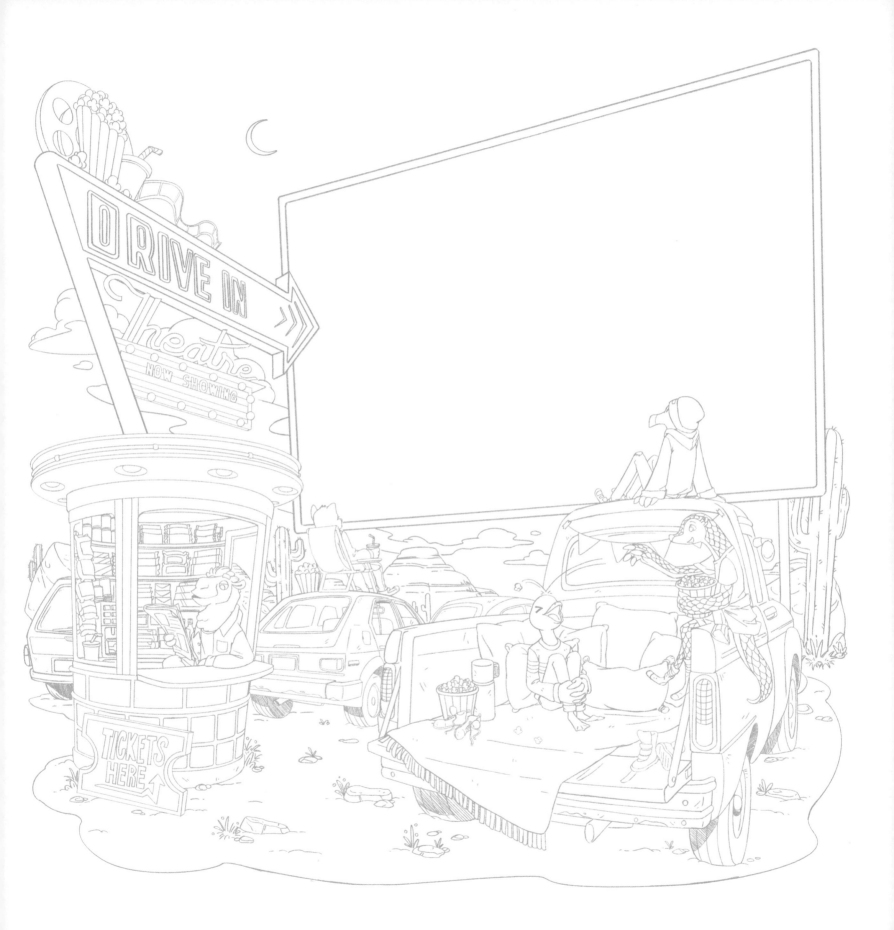

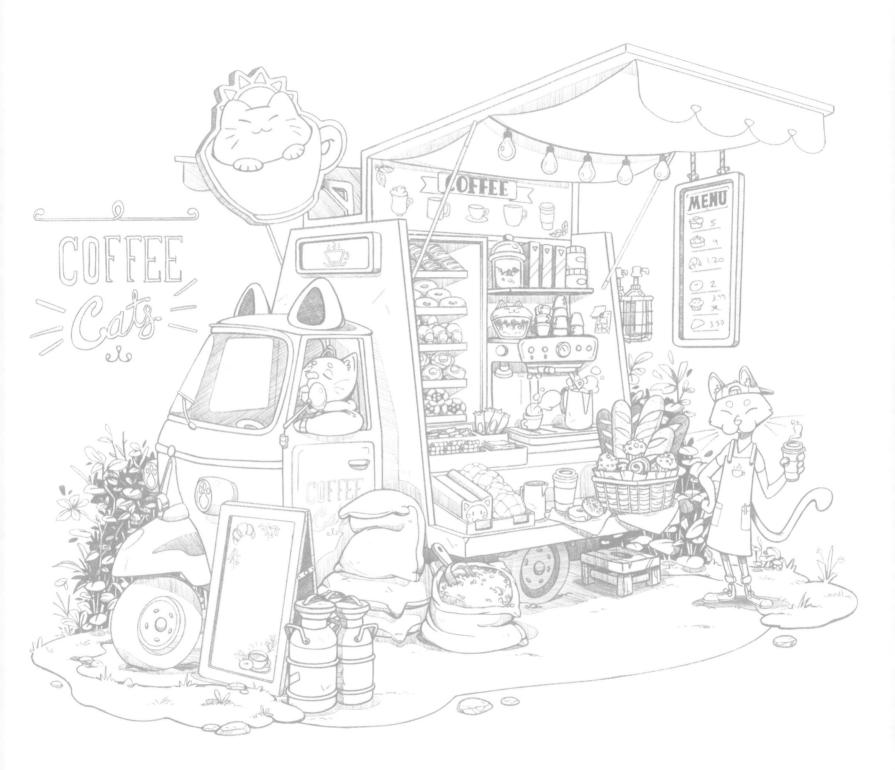

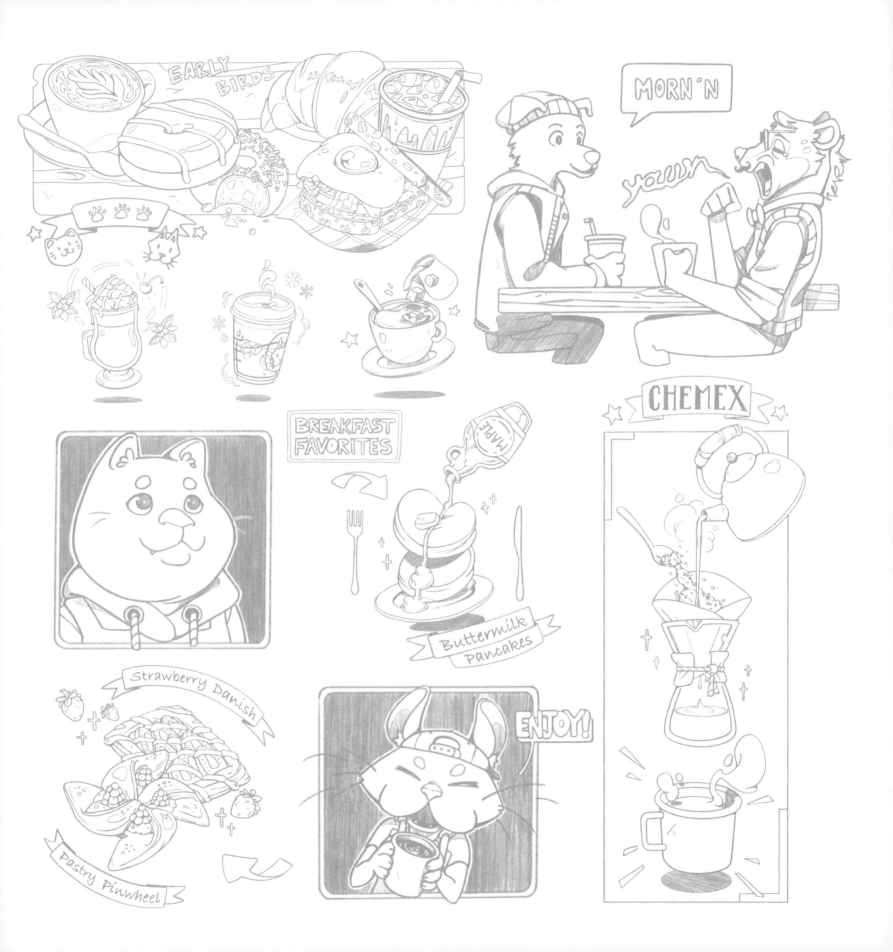

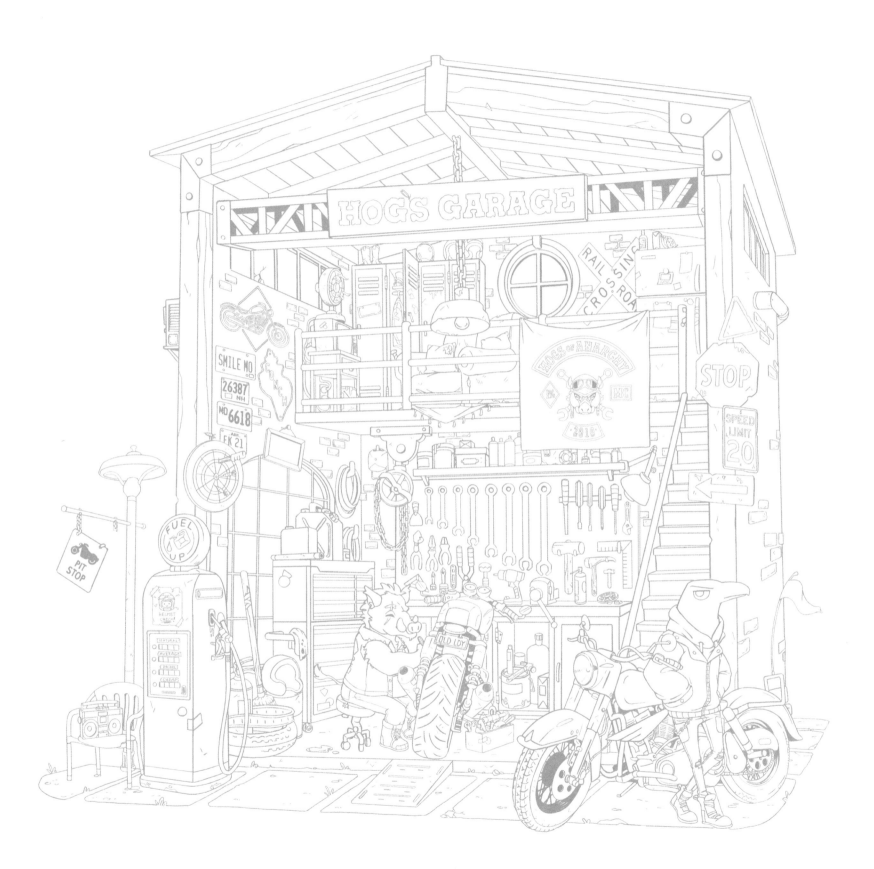

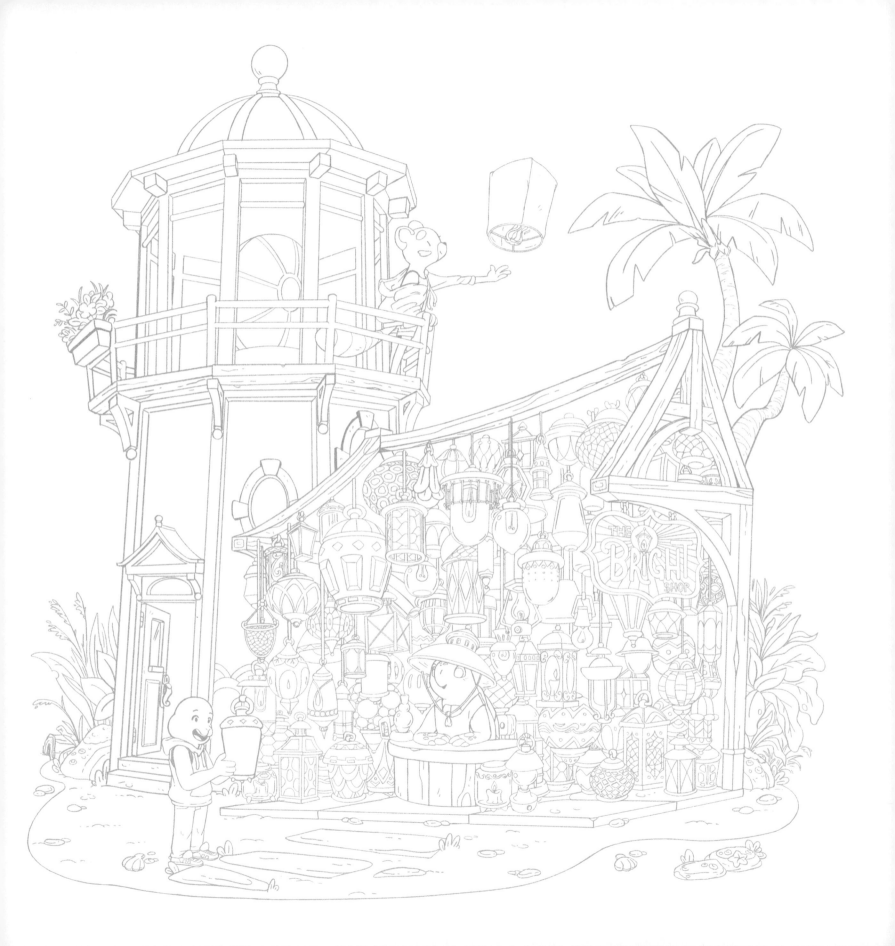

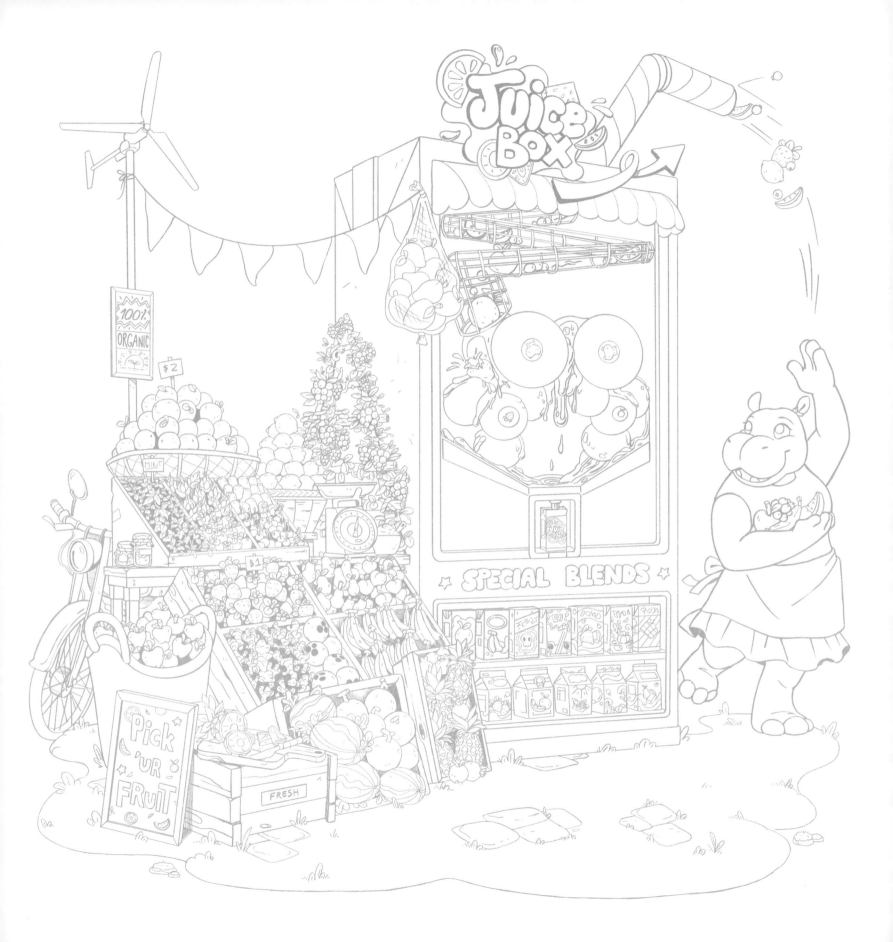

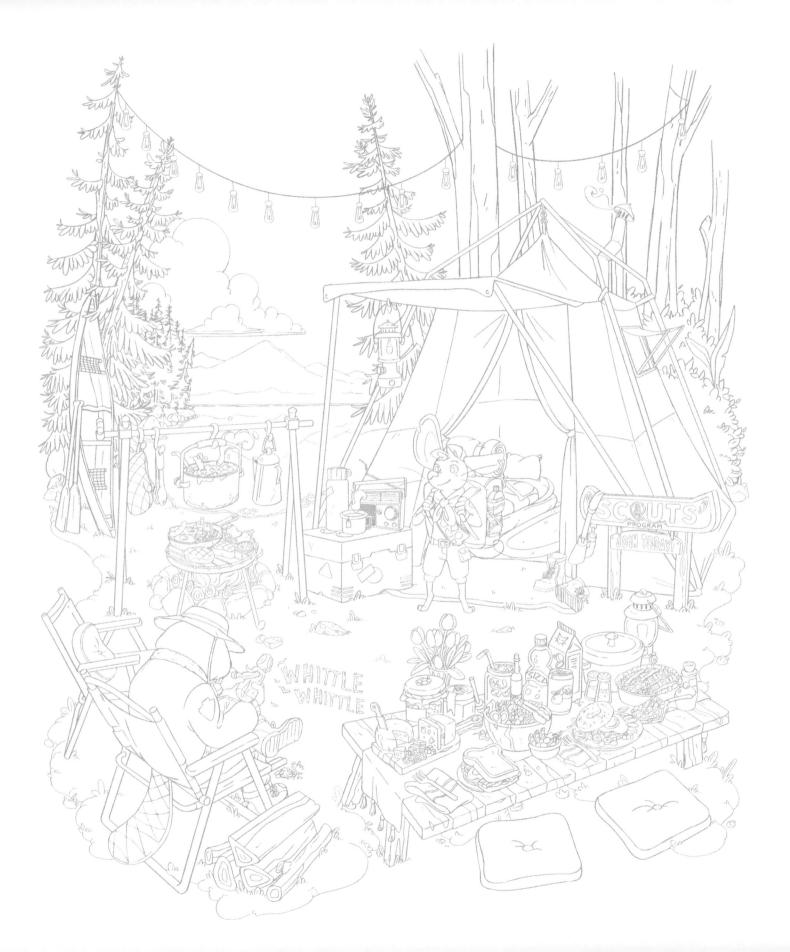

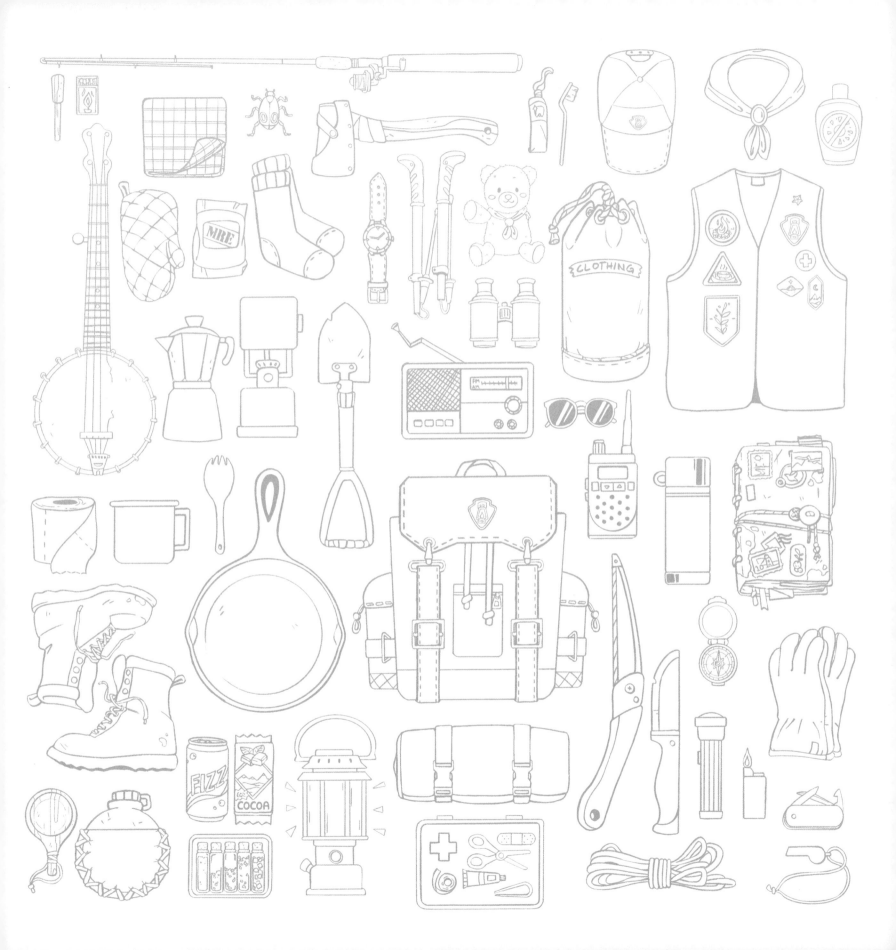

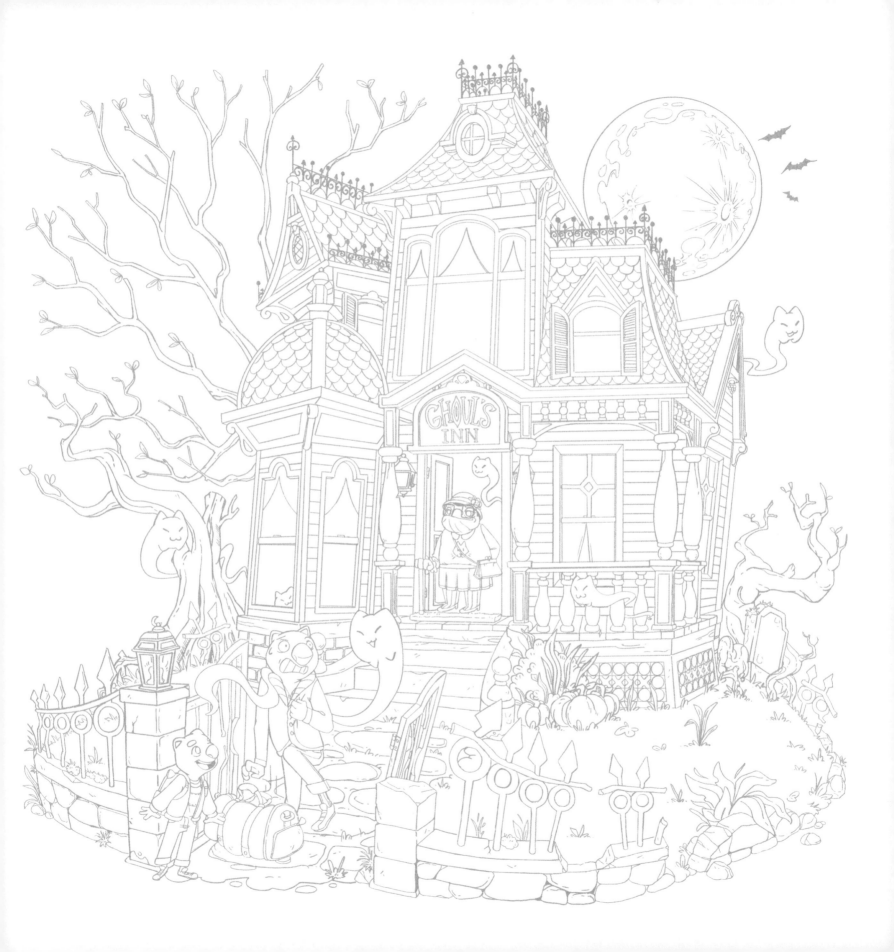

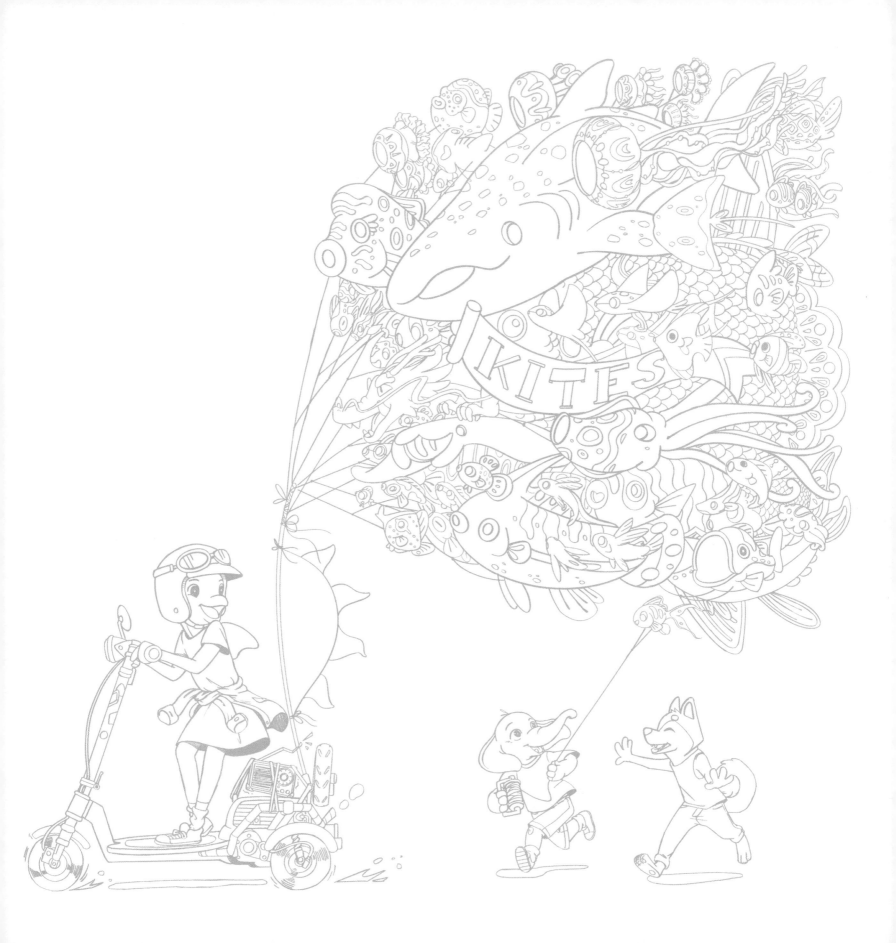

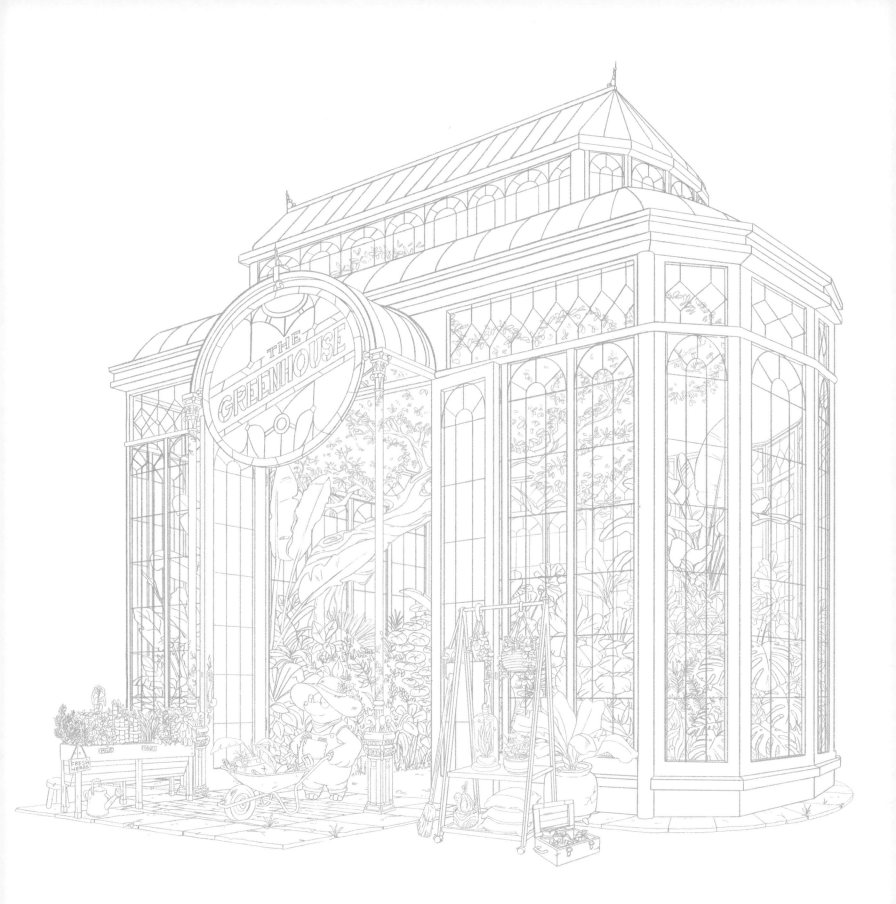

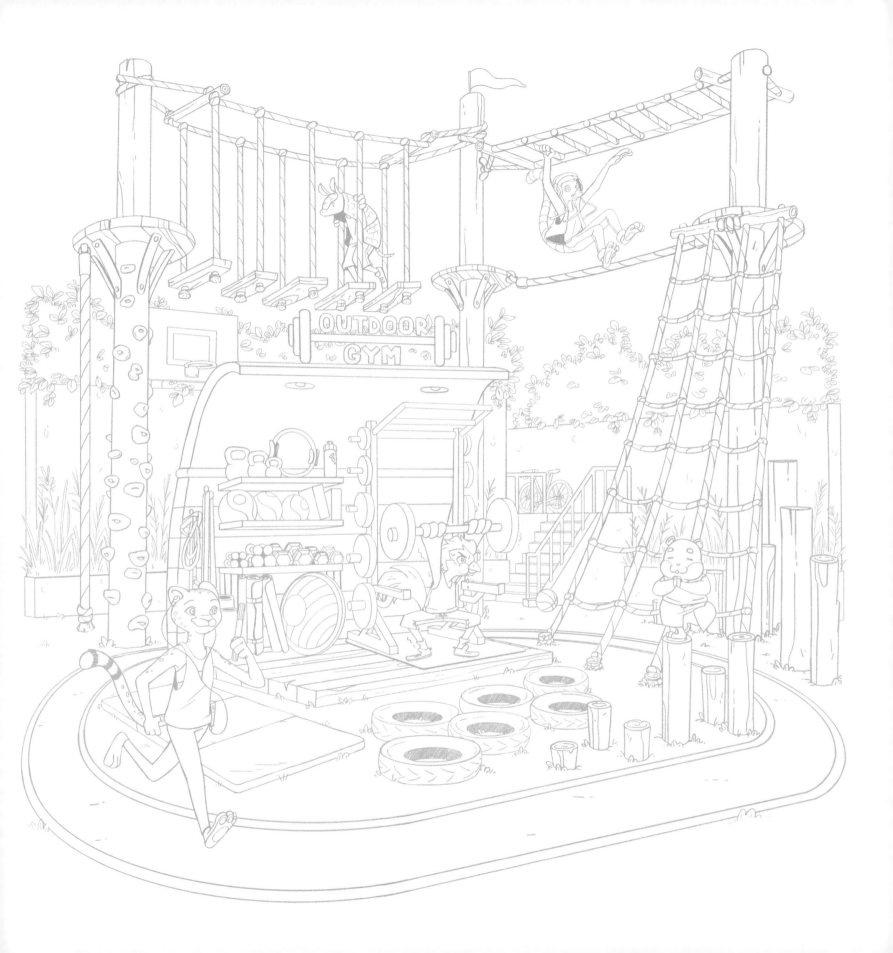

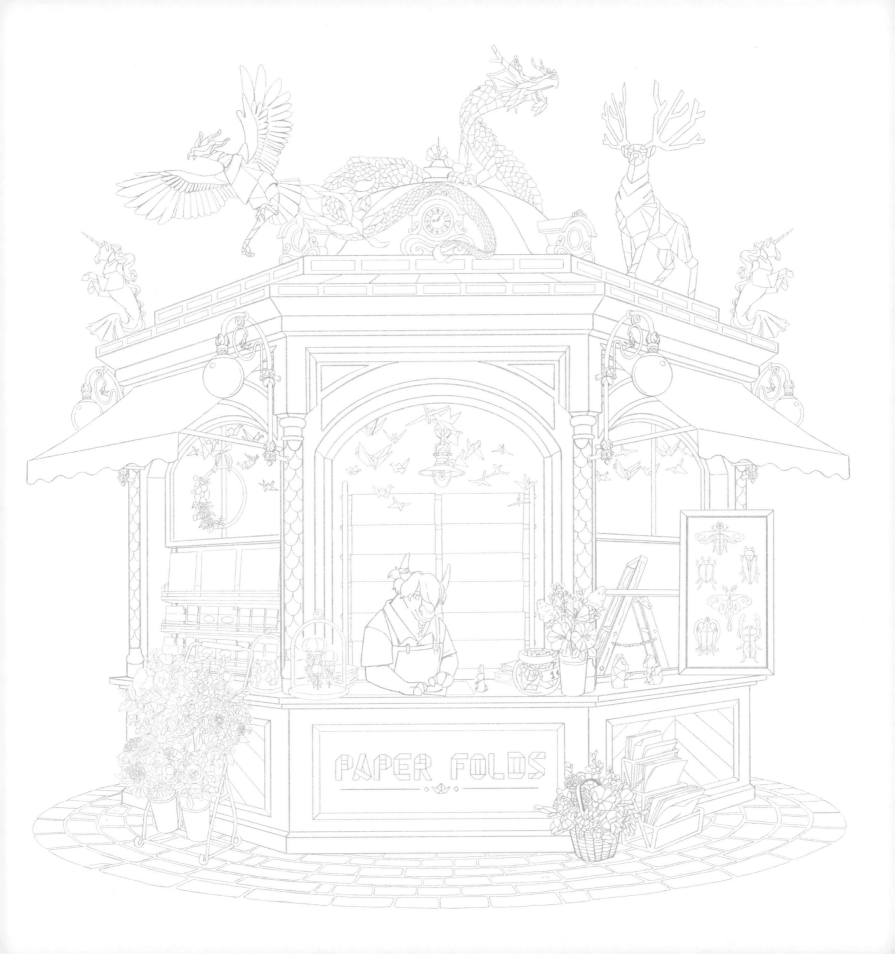

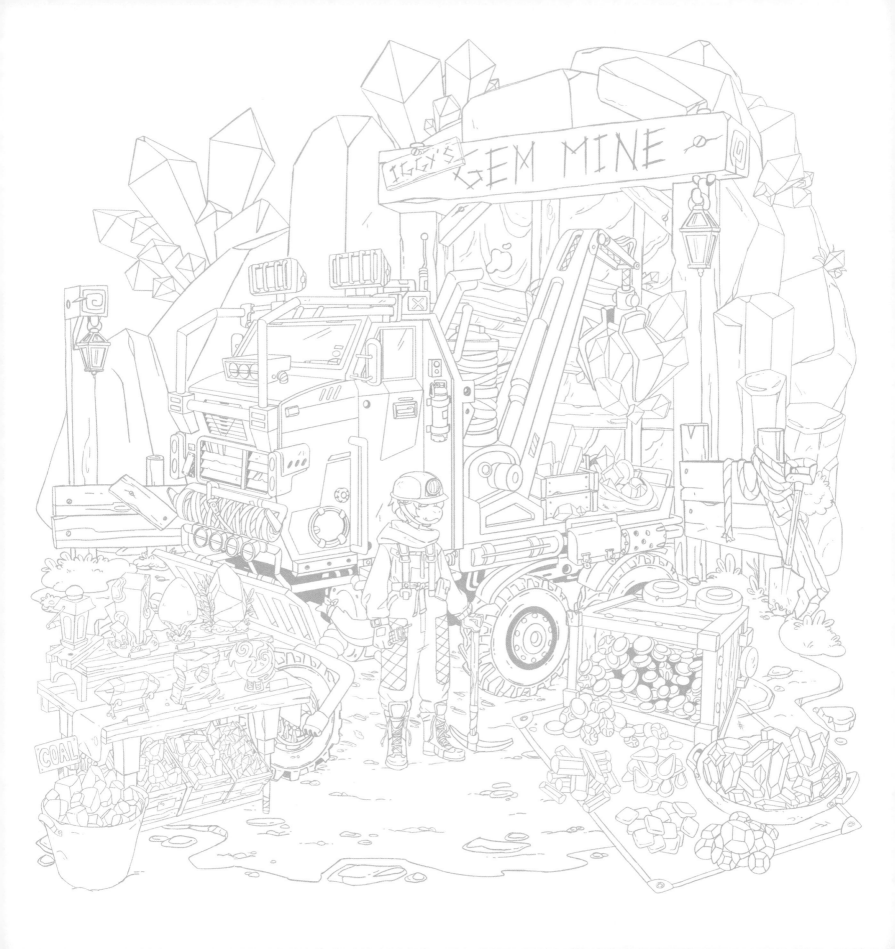

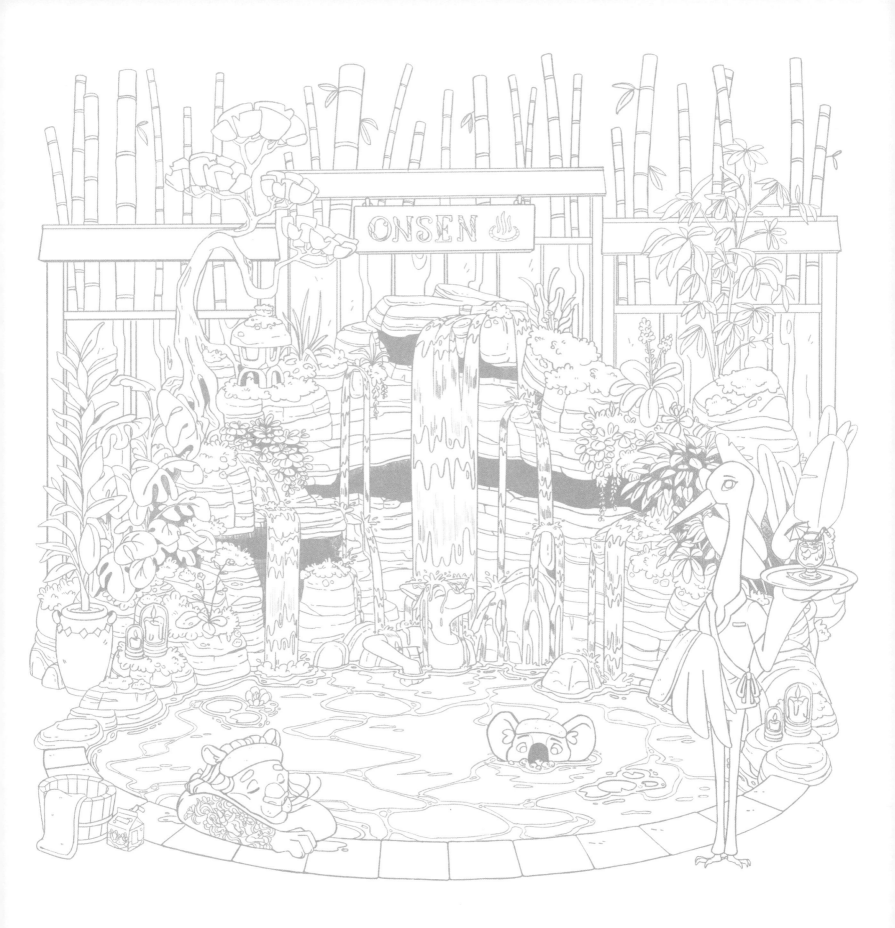

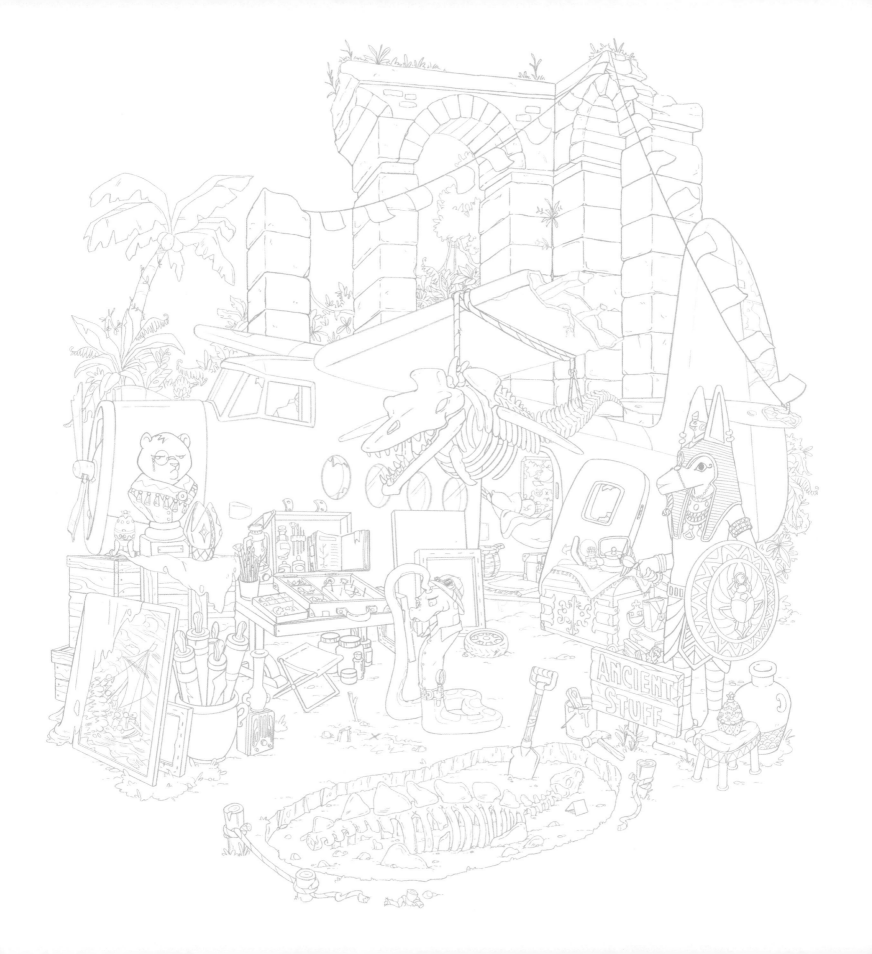

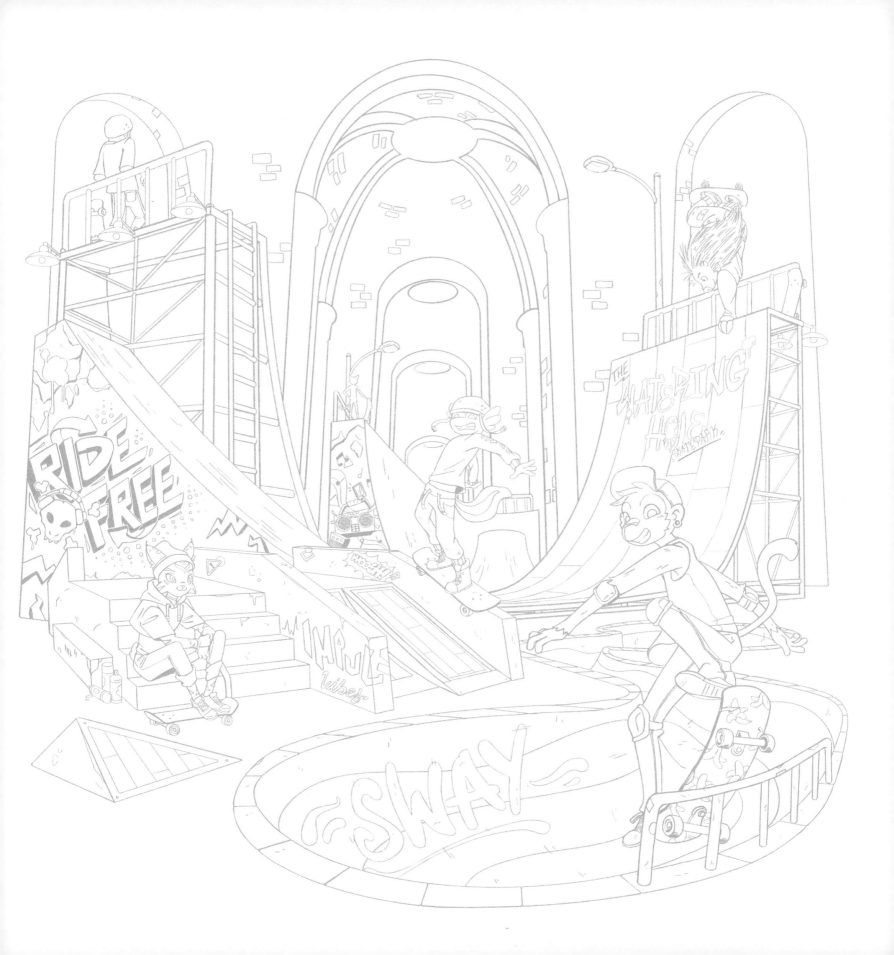

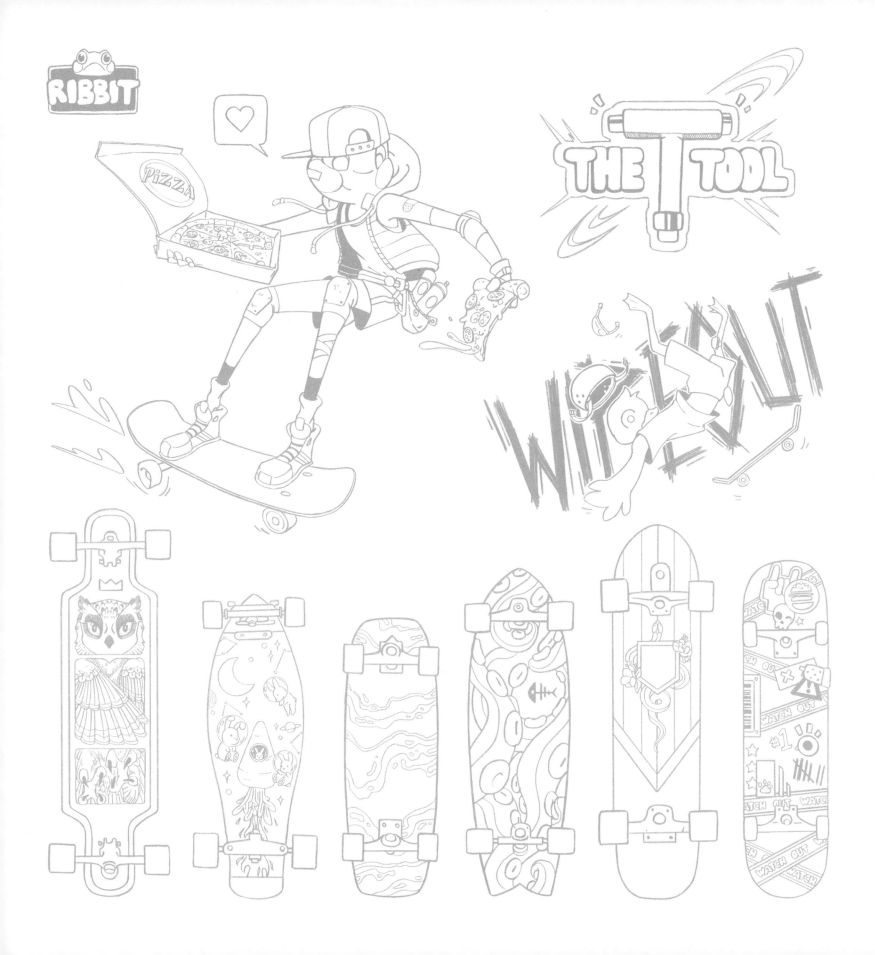

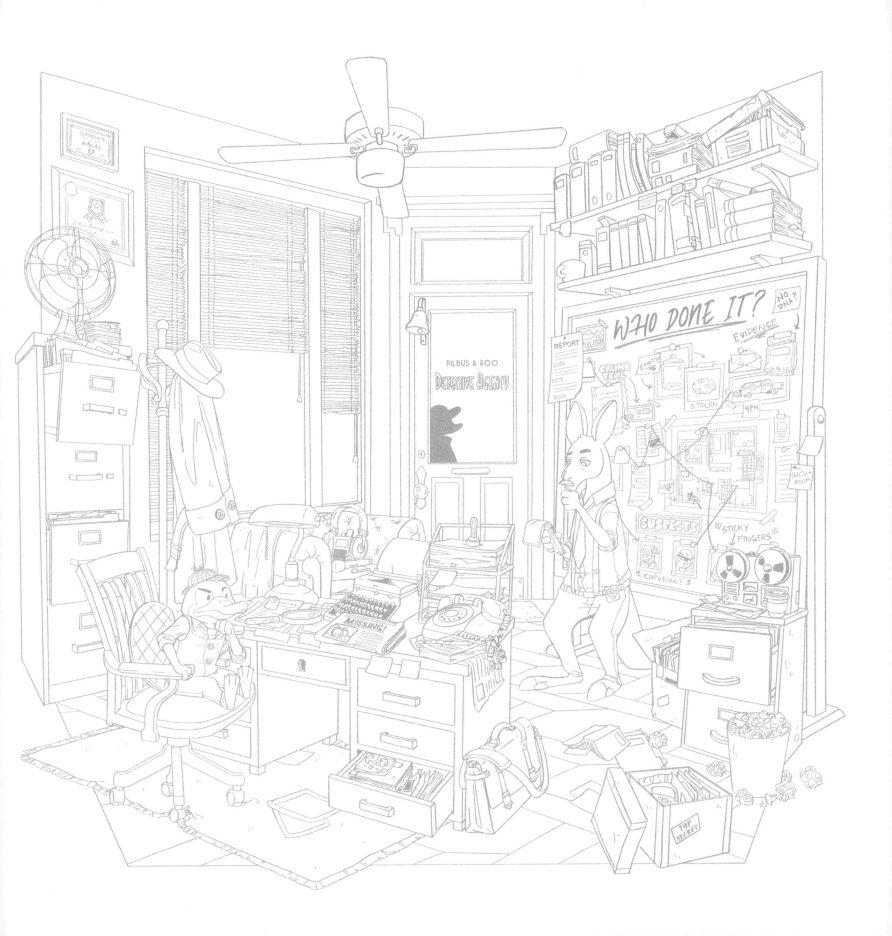

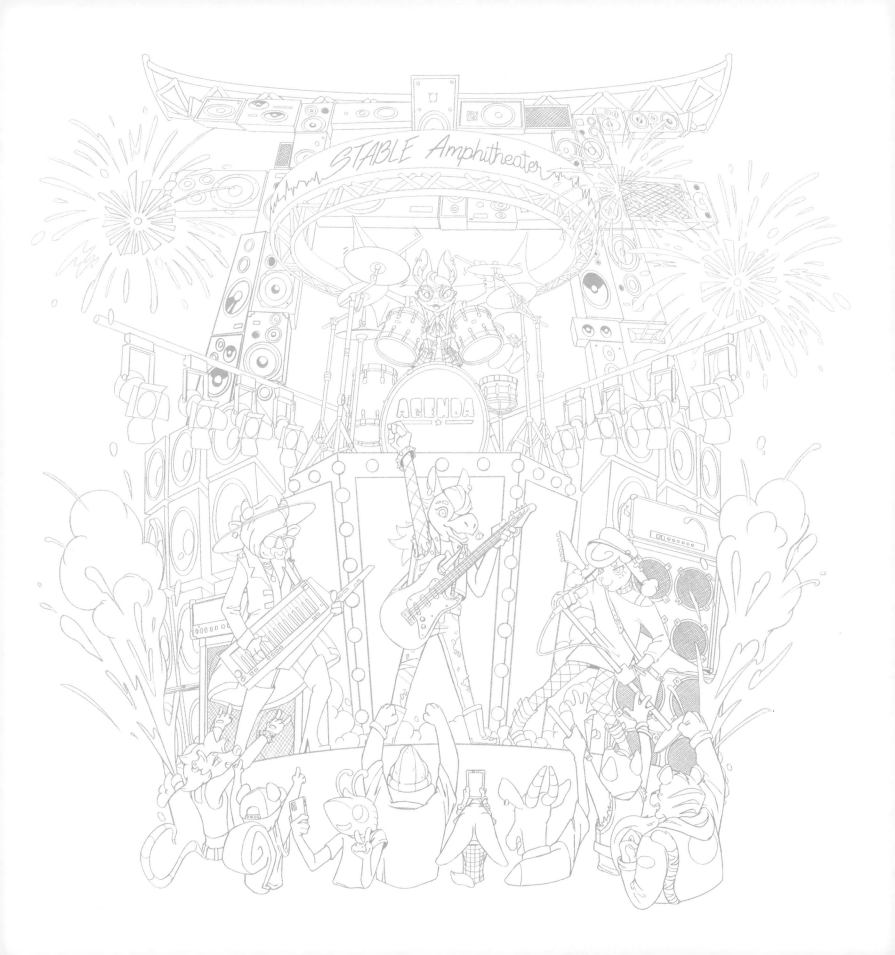

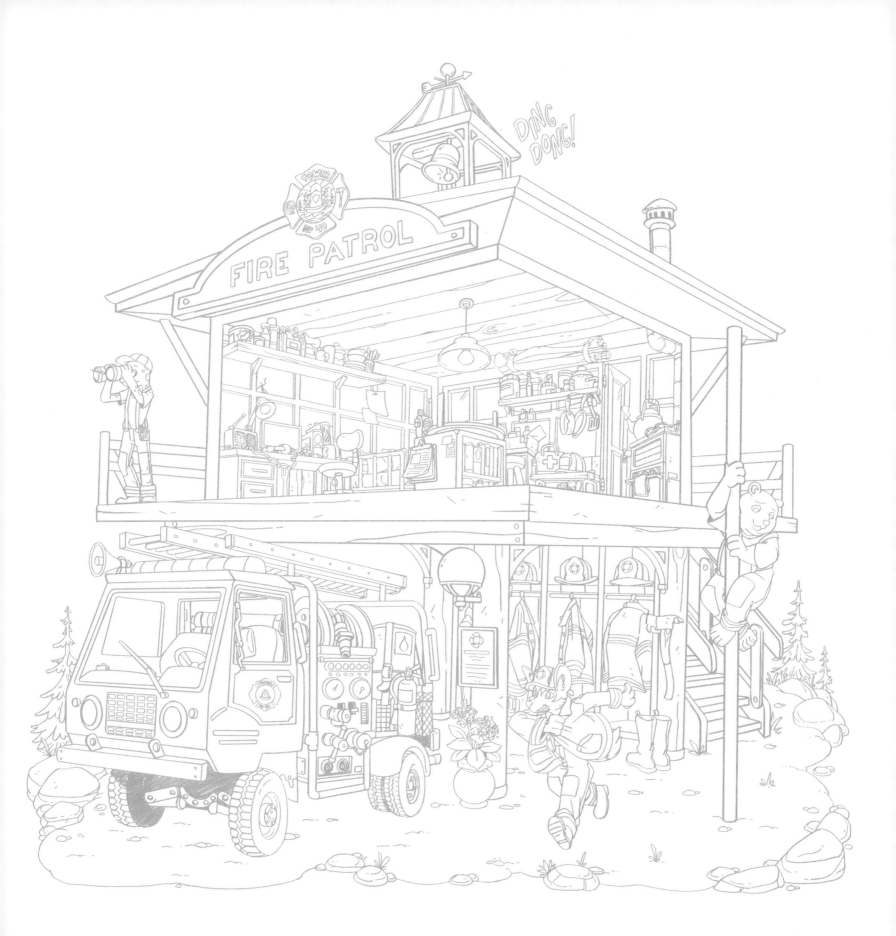

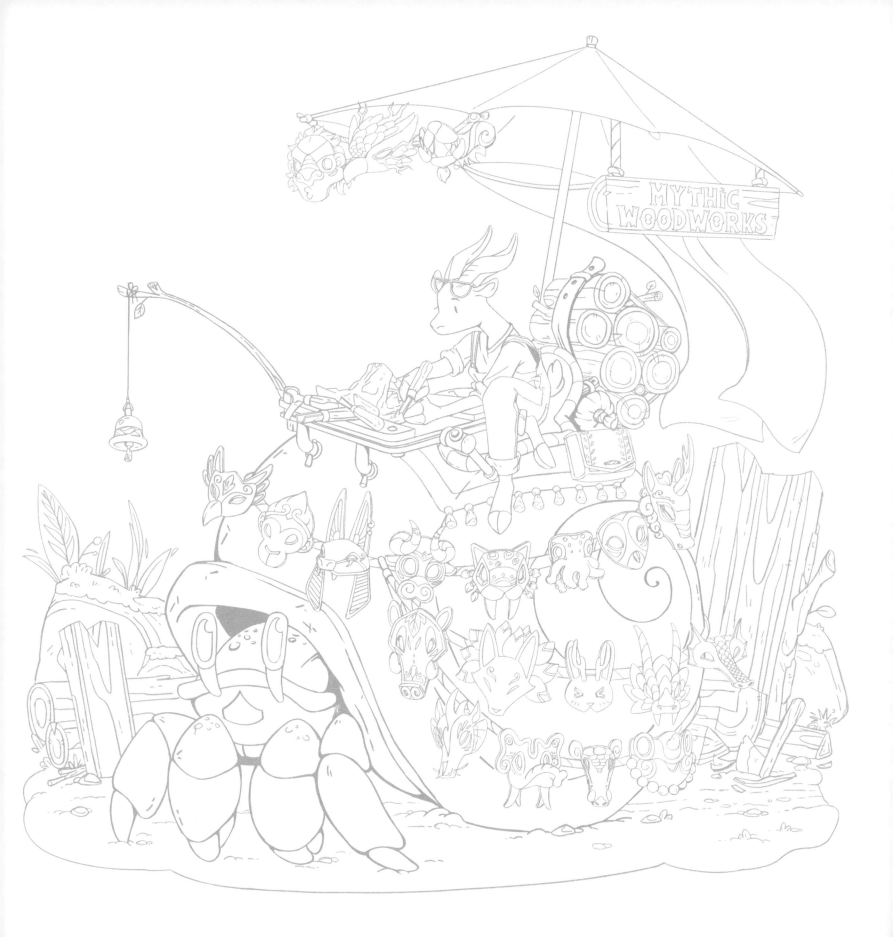

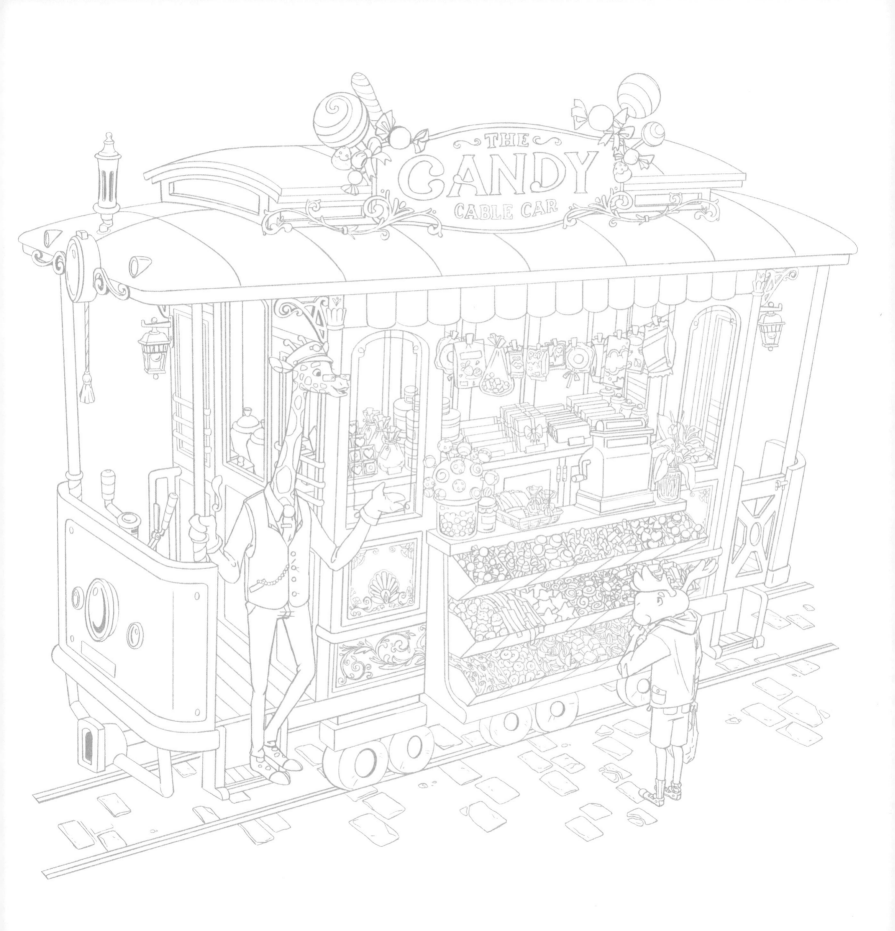

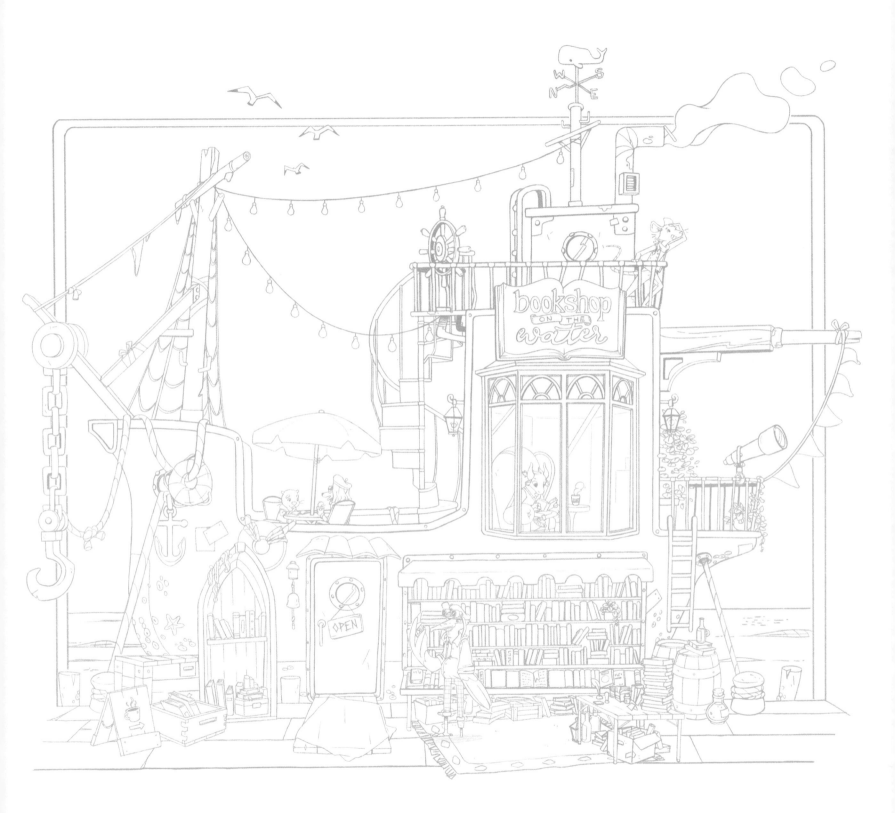

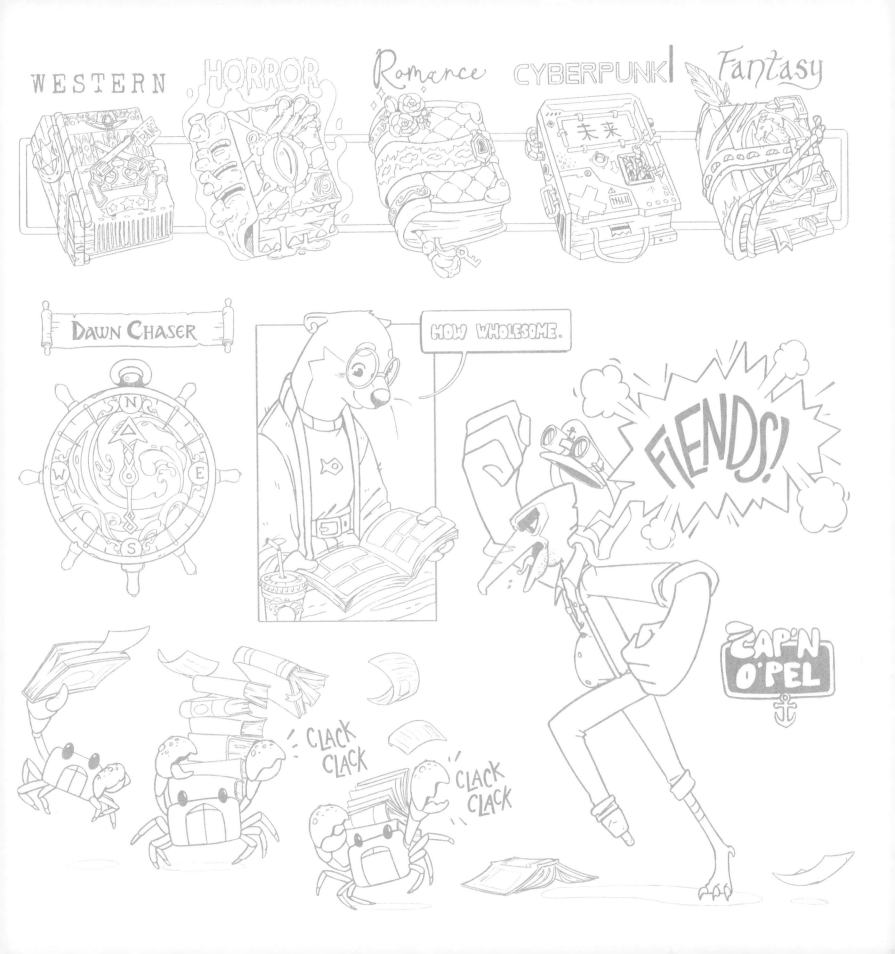

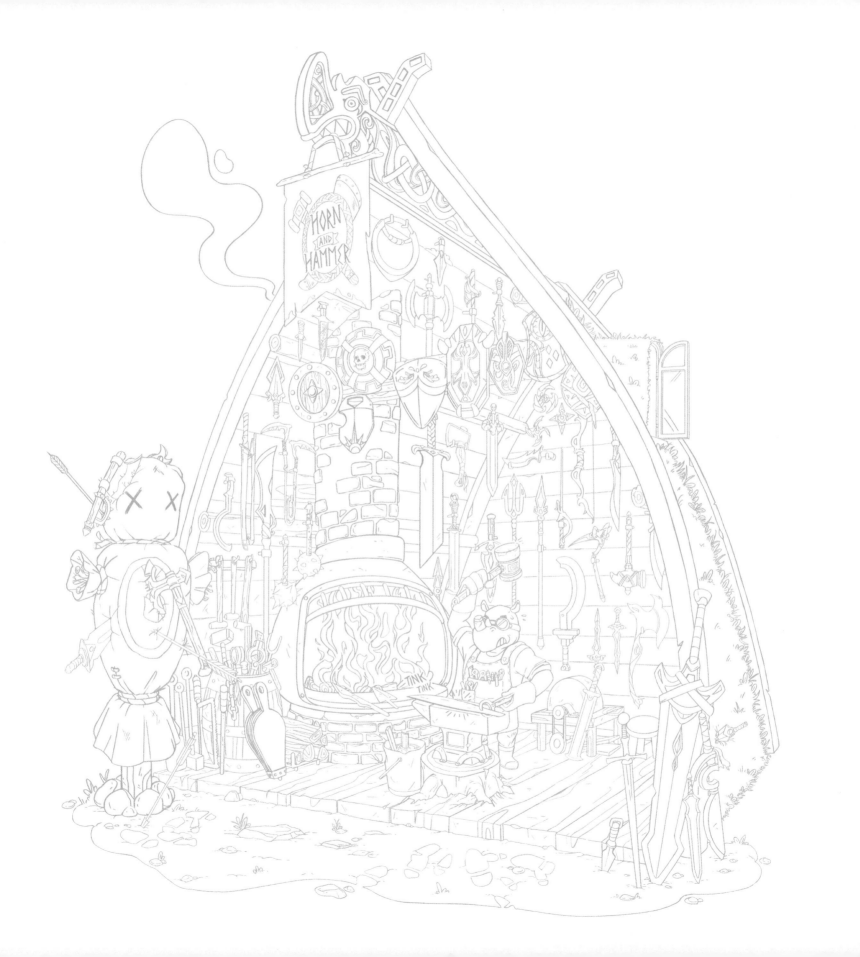

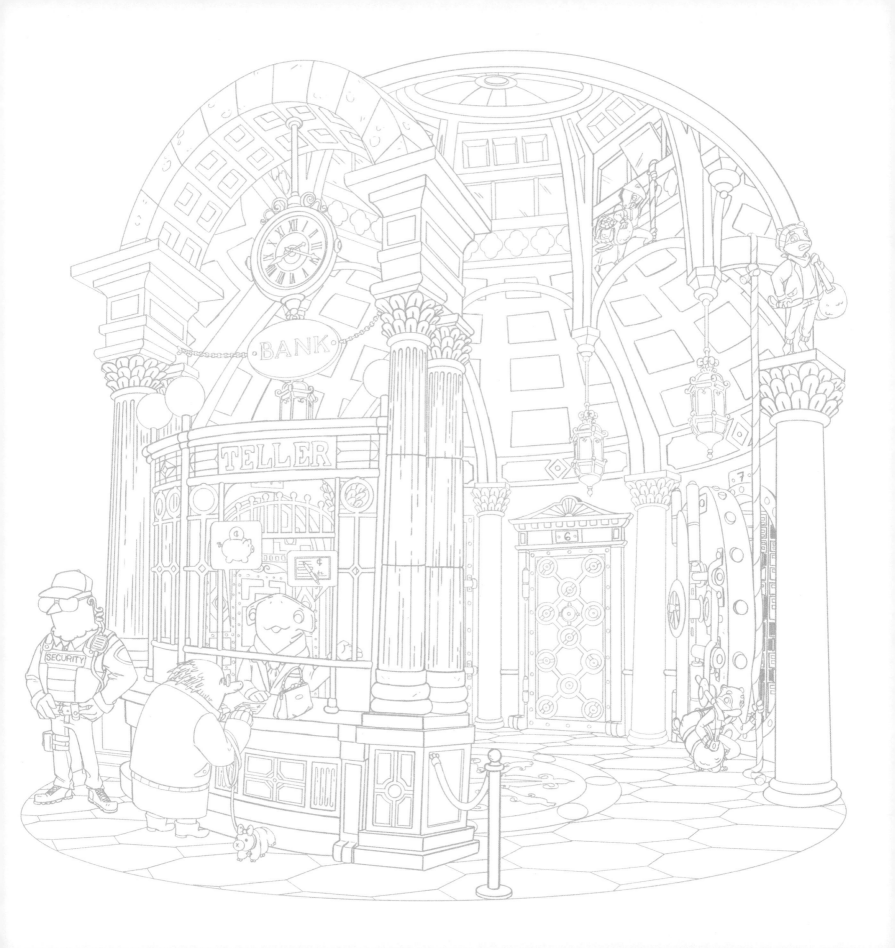

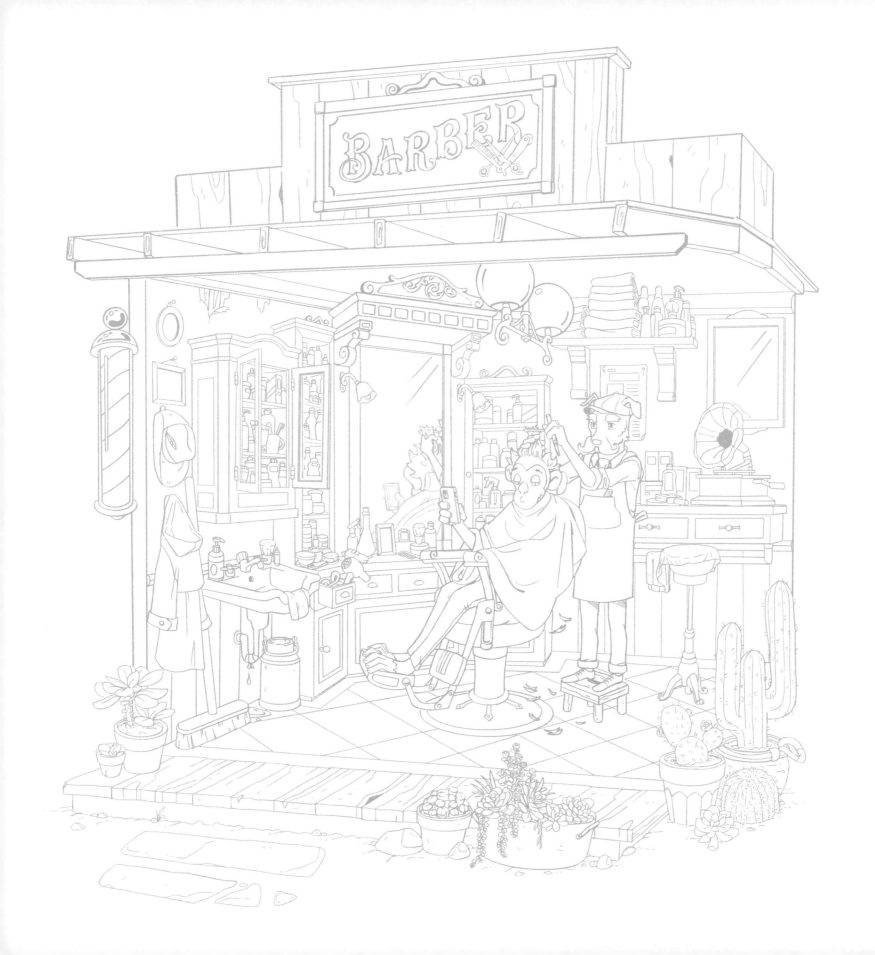

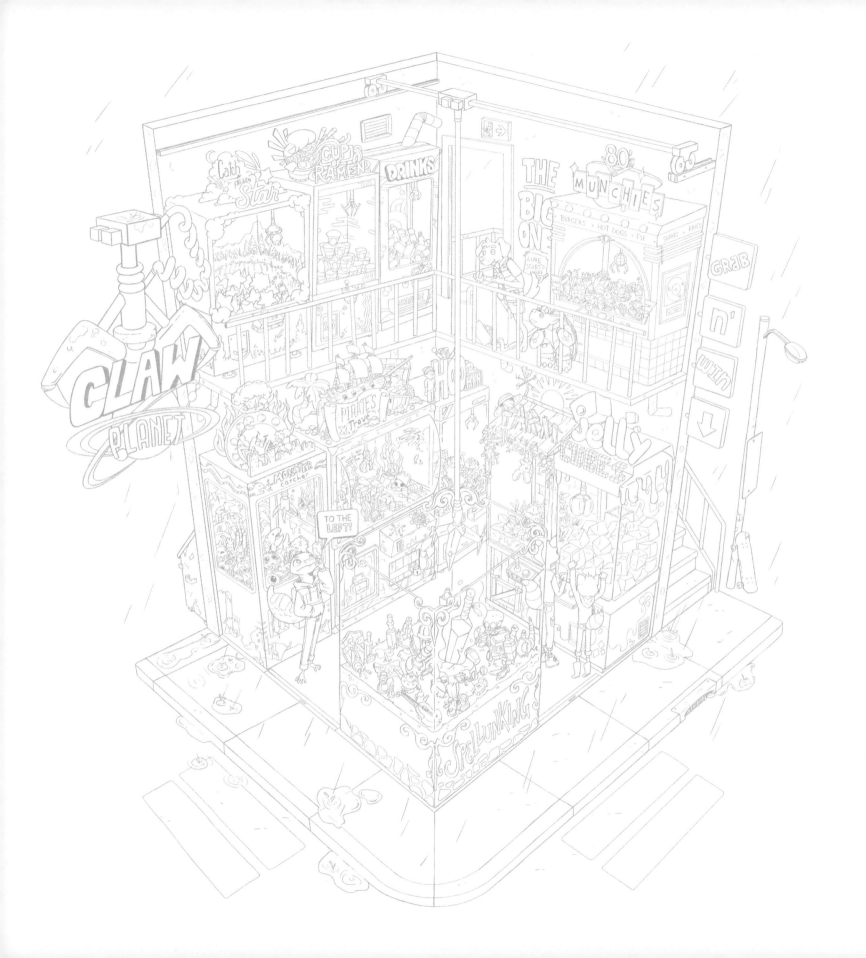

ACKNOWLEDGMENTS

First, the one who deserves all the praise is Jesus. This book wouldn't exist without you, from first thought to final pencil mark. Not a page was drawn without your provision. I just get to put my name on the cover.

Thank you, Mom. You supported me from the beginning to the end of this book, through milestone victories and times of fatigue. You provided a place for me to work, encouraged me to take breaks, and cared for my overall well-being.

Thank you, Dad, for your confidence in me before I even started the first page of this book. Both you and Mom have always encouraged me to pursue my career as an artist—how rare that is! Thank you for all your support.

Thank you to my "Seester." You are proof that laughter is good medicine. You refreshed my weary heart when I felt like throwing in the towel and celebrated my achievements even more than I did. You are truly my best friend. Many thanks to Drew, my brother-in-law, for empathizing with my excitements, fears, and frustrations throughout the process of creating this book. I appreciate that you are always genuinely interested in what I do.

Thank you to my editor, Lauren Appleton. You plucked this book's proposal out of the "snow slush" of submissions and decided to run with it. I'm grateful for your wisdom, honesty, and professionalism. You brought all the pieces together, including introducing me to my awesome agent, Jennifer Chen Tran. You've been a reliable navigator through what were, for me, the unfamiliar waters of publishing. Thank you for your encouragement, for answering all my questions, and for easing my worries while you walked beside me through the creation of this book.

Thank you to the TarcherPerigee team who had a hand in bringing this book into existence and out into the world. I'm honored to be a part of your mission of empowering people to live their best lives. Special thanks to Caroline Johnson for your cover design expertise, quick email responses, and overall professionalism in making this book stand out in a competitive marketplace.

Thank you to the Covenant College professors and staff. You laid the foundation not just for my education in art but also for my life.

Thank you to the Savannah College of Art and Design professors David Duncan, Ray Goto, Mark Kneece, John Larison, John Lowe, Ahmad Rashad Doucet, Robert Atkins, and David (Dove) McHargue. You not only taught me practical skills—and the very concept of inking!—but also prepared me to make a career out of drawing. Thank you for the time and energy you invested in me; I hope this book feels like an accomplishment for you as much as it does for me.

I'm extremely grateful to my mentor and sister in Christ. Thank you for teaching me to look underneath the bed skirt.

Thank you to my peers who encouraged me—I continue to apply what I've learned from my time with you to this book. Thank you to my friends. Y'all celebrated every little victory and milestone along the way like it was your own. Thank you to "Mom's friends." You supported and encouraged me as if I were your own kid. Thank you to every barista who served me a cup of coffee while I labored over this book. Thank you to anyone who's ever given me an encouraging word about my artwork. It means a lot to an artist who is their own worst critic.

And thank YOU, the reader, the artist, for your support by picking up this book. I hope the time you spend here is a blessing in your life.

ABOUT THE AUTHOR

Brittany Meredith is an illustrator and a storyteller. Growing up, she loved to draw and read copious amounts of manga—and she always knew she wanted to pursue a career in art. After graduating in 2017 with a bachelor's degree in art from Covenant College, she continued her education by pursuing a master of fine arts in sequential art at Savannah College of Art and Design. She was raised and continues to live in Georgia, close to her family and with Theo the cat. Currently she is planning more art projects and enjoying long walks in good weather. She invites you to follow her on Instagram @bt_meredith.